OUTDOOR PAINTING

WITH
JAMES
FLETCHER-WATSON

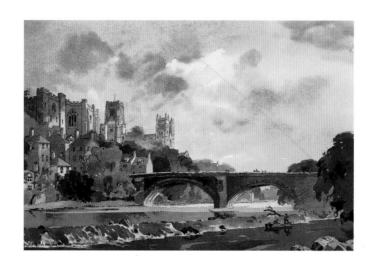

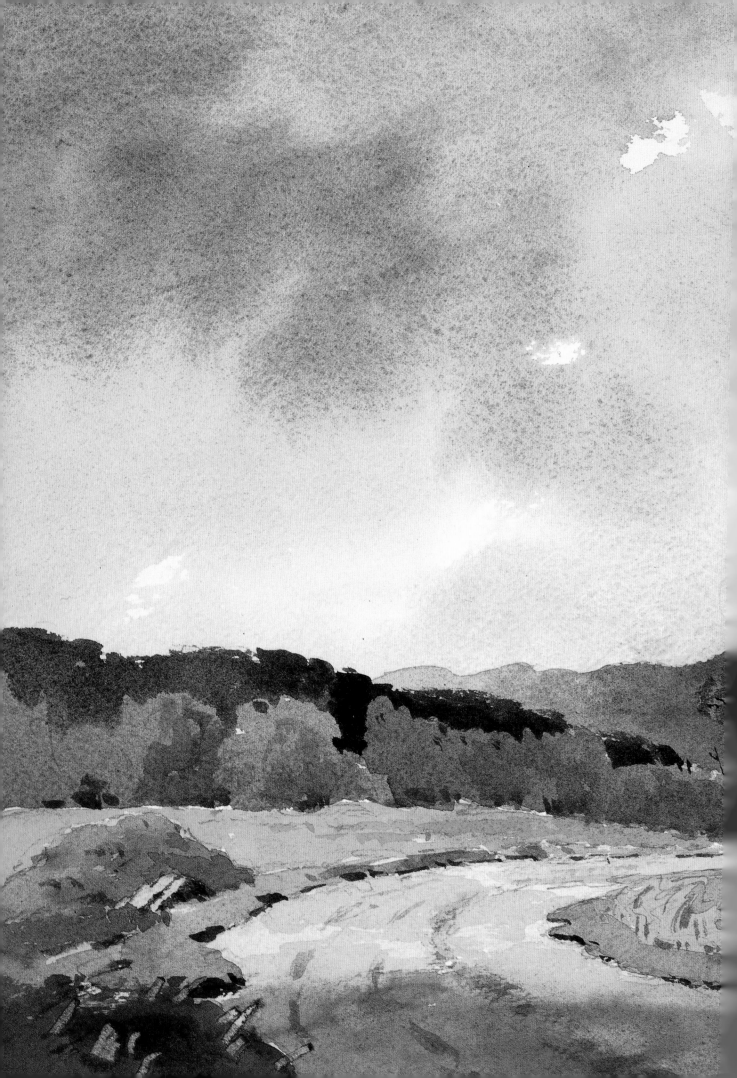

OUTDOOR PAINTING

— WITH —

JAMES FLETCHER-WATSON

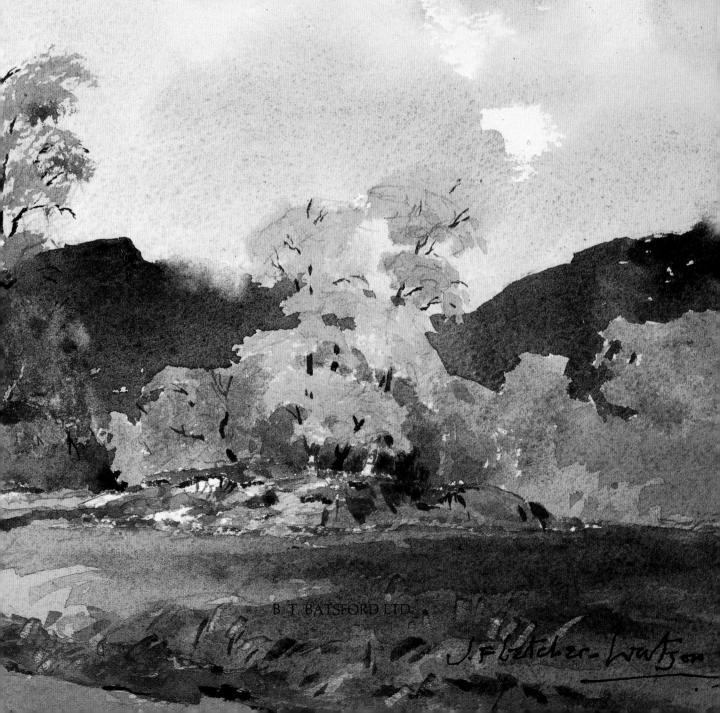

B. T. BATSFORD LTD.

First published 1993

© James Fletcher-Watson 1993

All rights reserved. No part of this
publication may be reproduced, in
any form or by any means, without
permission from the Publisher.

Typeset by Servis Filmsetting Ltd,
Manchester
and printed in Hong Kong

Published by
B. T. Batsford Ltd
4 Fitzhardinge Street
London W1H 0AH

A catalogue record for this book is
available from the British Library

ISBN 0 7134 6983 8

Complementary to this book is a
sixty-minute video, *Outdoor Painting*,
in which James Fletcher-Watson can
be seen painting some of the types
of subject illustrated in this book.
Produced by APV Films, the video is
available from the artist at the
following address: Windrush House,
Windrush, Near Burford, Oxon
OX18 4TU. *The Magic of Watercolour*
video is also available from this
address. The price of each video is
£26, including postage.

Page 1
*Durham Cathedral and Castle from the North-
West.* 317 mm × 476 mm (12½ in × 18¾ in)

Pages 2–3
Glen Strathfarrar, Inverness-shire.
317 mm × 476 mm (12½ in × 18¾ in)

CONTENTS

INTRODUCTION

I am glad to have an opportunity of writing another book because I want to stress the principle I have always held that it is better to paint landscapes in watercolour *out of doors* far more often than painting indoors in the studio. When we are outside, we can feel the mood of nature and, with a bit of luck (and a certain amount of experience!), we can convey that mood on to our paper.

The other point I want to make in this new book is to get people to seize the opportunity of catching the passing subject. You may never get the chance again, although you think you will. If there is not time to paint, do a quick pencil drawing in a small sketchbook. You can often do a very good watercolour painting from this at home days or even years later. The sketch will also serve as a reminder of where to go back for a good paintable subject when you *do* have the time.

To help you in your quest to paint good watercolours, I have brought together a great number of pictures, both paintings and pencil sketches, in order to demonstrate the tremendous variety of subject matter that exists both at home in the British Isles and abroad in America, Australia, Italy and on the Continent. You will find subjects in this book ranging from a humble country road in the Cotswolds, or a simple gate and a tree in Norfolk, to an exciting mountain range in Scotland, the delightful architecture of New England or Durham's glorious Norman cathedral towering high above the river.

In nearly every chapter, I describe how at least one of the pictures is painted and usually what the weather was like when I painted it. We complain of our climate in Britain, but sometimes wet stormy weather is good weather for the artist, and we must learn to paint from inside the car so as not to lose the drama of a stormy day. On page 9 I describe how I make my car adaptable for such use.

This book should be useful to the beginner as well as the advanced painter because I have included some very simple subjects as well as a few complicated ones. I have mentioned a great many colour mixes and how they should be applied, either with plenty of water or dry brushwork with very little water. I have talked about the main principles governing the making of a good landscape: composition, tone value, colour, atmosphere, perspective and, last but not least, technique.

Batsford, my publishers, have been generous with the number of colour illustrations and this has helped me to demonstrate more than ever before how, by gradual, persevering steps, you can all produce lovely watercolours.

J. Fletcher-Watson

R.I., R.B.A.

FOREWORD

When I was asked to write this foreword, I was completely overwhelmed. James Fletcher-Watson's watercolours fascinate and inspire; they capture the heart of every subject, reaching out to the viewer with warmth, excitement and yet total peacefulness.

I love to be with nature; to smell the earth, breathe the air, feel cleansed by the rain and enriched by the sun. Perhaps that is why I really feel a longing to be able one day, after many lessons, to try to capture the same magical views that James achieves when he explores the Great Outdoors.

James Fletcher-Watson's versatility has no boundaries. He travels from the wilds of Scotland to the vastness of Australia to feed his thirst for perfection and creativity.

I cherish every minute and feel so honoured to have an opportunity to watch, listen and learn – and I do so hope this book brings you as much help as it does for me.

Sarah,

H.R.H. The Duchess of York

1

MATERIALS AND EQUIPMENT

IN this chapter I discuss the materials that I use – pencils, brushes, my palette, paper, etc. I suggest that you gather together the same items, so that you can follow my techniques and ideas; then you can start to work on your own sketches and paintings.

Pencils

The grades I find most useful are HB, B, 2B, 5B and 6B.

Pens

A 'relief' nib or an old fountain pen is useful for doing a pen-and-wash picture.

Felt pens by Edding or Staedtler are reliable. Be sure to ask for the waterproof type.

Eraser

Faber-Castell is an excellent make. At the end of a painting, I sometimes lift out pencil guide-lines, and the occasional mistake!

Brushes

Sizes 1, 3, 5, 7 and 10 are a minimum, and a no. 6 squirrel mop brush is excellent for skies, trees, etc. (I do use a few more brushes myself sometimes.)

Sable is best, but a synthetic brush at a quarter the price is adequate. A small oil-painter's bristle brush is invaluable for lifting off colour.

Paints

The choice of colours is a very personal matter and different artists like different colours. I give you my own choice so that you can try out my mixes, and then later on you may like to change these as you develop your own style.

In previous books I have quoted 12 colours, but I now have a list of 14 which I like using. I have added *Cerulean Blue* and *Raw Umber*.

1 *Cadmium Lemon*
2 *Cadmium Yellow*
3 *Raw Sienna*
4 *Raw Umber*
5 *Burnt Sienna*
6 *Burnt Umber*
7 *Light Red*
8 *Indian Red*
9 *Rose Madder*
10 *Cobalt Blue*
11 *Cerulean Blue*
12 *French Ultramarine*
13 *Winsor Blue*
14 *Payne's Gray*

A chart showing these colours can be seen overleaf. I give details of colour mixes during the course of the book.

Paintbox

I prefer the old style of paintbox with two lids which open out into palettes – the larger the better. They have individual pans of paint which can be replenished from tubes as they are used.

Paper

I mostly use Whatman Rough, 200 lb weight. I find its whiteness suits many of the subjects I paint; it is especially good for cloudy skies.

Winsor and Newton artists' watercolour paper in 260 lb weight is also very pleasant to use. It is slightly absorbent, which can produce good effects. Bockingford remains a good uncostly paper which I can recommend.

Sketchbooks

By this I mean books for drawing only, not for painting. I believe one should do a lot of quick pencil sketches and I will have a lot to say on this subject in Chapter 2.

A good small sketchbook is a spiral-back A6 size (cartridge paper), which will fit in most pockets. I mostly use an A5, which is a little larger – 15 cm × 20·5 cm (6 in × 8$\frac{1}{4}$ in). The make I like is Daler, with smooth cartridge paper. There are larger sizes, of course.

Easel

I have a French make of oil-painter's easel, which is the size of a large briefcase when folded. It has a sliding drawer which, when set up for use, is just right to hold my paintbox. It is rather heavy to carry, but it is very

① CADMIUM LEMON	② CADMIUM YELLOW	③ RAW SIENNA	④ RAW UMBER	⑤ BURNT SIENNA	⑥ BURNT UMBER	⑦ LIGHT RED
⑧ INDIAN RED	⑨ ROSE MADDER	⑩ COBALT BLUE	⑪ CERULEAN BLUE	⑫ FRENCH ULTRAMARINE	⑬ WINSOR BLUE	⑭ PAYNE'S GRAY

1a A chart showing my full range of colours

good at adjusting at different angles for a drawing board. There are many makes to choose from and personally I very seldom use one.

Chair or stool

I prefer working out of doors in a sitting position on a chair that is close to the ground, so that I can reach my paints and brushes which are laid out on an old towel.

Drawing board

I use a stiff piece of cardboard on which to fix the watercolour paper with large paperclips.

Water

An old coffee jar, 1 litre or about 2 pints, is ideal. It must have a watertight screw top.

Penknife

Any good make of knife will do. I use it for scratching out when I am painting, as well as for sharpening pencils.

Blotting paper

Always useful to have for emergencies or for partly drying an area that is too wet.

Brush case

Most art shops sell tube cases that protect your brushes – a most important item.

Carrying bag

This should be a satchel type, with a flat bottom on which your paintbox can sit in a level position – your paintbox may contain soft paint that could run and make a mess of the box. The bag should have a shoulder strap.

I like one large enough to carry a small thermos and sandwiches as well as all my painting gear!

Fixative

It is important to have a tin of this spray mixture to fix your pencil sketches and prevent them from smudging, especially the ones drawn with a 6B!

Painting umbrella

The type to get is a fisherman's umbrella from a fishing shop. They are large and adjustable and can be fixed at any angle. I always have one in the car.

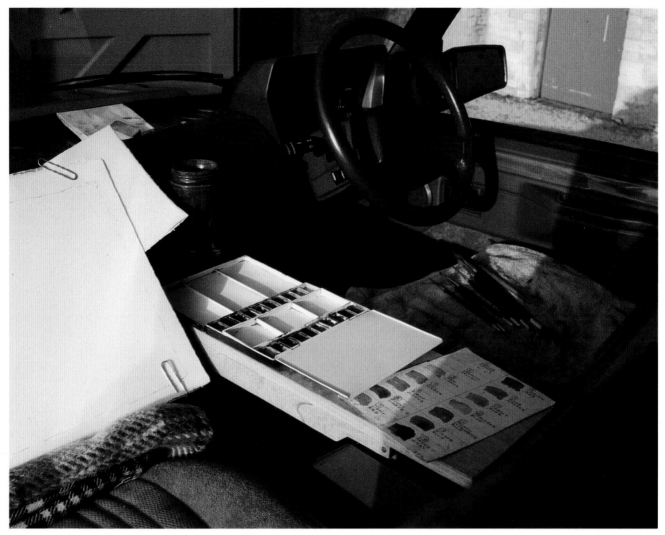

1 Painting from inside the car

Sponge

A small sponge, as sold in art shops, is useful for wiping out paint and for cleaning your paintbox while you are painting.

Masking fluid

I have only recently started using this. It is not essential, but in Chapter 8 of this book I demonstrate how it can be very helpful.

Painting from inside the car

In bad weather it is invaluable to be able to paint from inside your car. I have managed many a good painting in the Lake District in pouring rain, and in the Cotswolds on a freezing day in deep snow from the safety of the car interior.

Figure 1 shows the front of my car. I have a specially made wooden shelf that fixes between the two front seats; it is level and my paintbox and water jar stand on it quite safely. The brushes rest on some towelling spread on the driver's seat. I sit on the passenger seat, holding the painting board at a suitable angle against the dashboard. I have an excellent view of the landscape through the windscreen. The car heater can be used to dry washes quite easily.

When I am buying a new car, I always insist that it must be possible to rig up such a shelf between the front seats. So far I have always met with excellent co-operation from car salesmen.

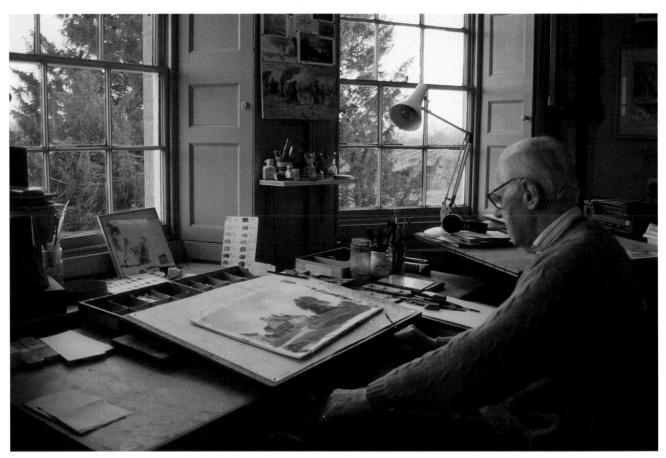

2 My studio at Windrush

The studio

Figure 2 is a view of my Windrush studio, where I am sitting at my work desk with a north-east light coming through the windows in front of me. I have two angle-poise lamps with daylight bulbs, which enable me to paint at night quite happily when I wish.

On my right are my brushes and large paintbox, and above the drawing board are tubes of paint in compartments for the different colours. Also on the table is a large water jar and some extra brushes. Further behind me in the room are racks for pictures and masses of bookshelves. It is altogether an ideal studio.

Now we have finished with materials and equipment, we can get on with the serious but enjoyable business of painting pictures. But before the actual painting begins, I want to say a word or two about pencil sketches. If we are going to be good watercolour painters, we must be able to make good pencil drawings as well; quite apart from anything else, they are extremely useful things to have for future reference.

3 *Farmhouse at Colomby, Normandy*

2

SKETCHING IN PENCIL

Quick pencil jottings in small sketchbooks and more careful pencil drawings as reference from which to paint a watercolour later

I have always advocated making quick pencil drawings in small sketchbooks in my previous books and when I am taking outdoor painting courses, but I don't think a lot of people have taken me very seriously. Perhaps they think that pencil drawing is dull. I am giving a whole chapter to this subject as I want to emphasize its real importance and the fact that pencil sketching does give you very real pleasure.

There are various reasons for making pencil sketches. If you are a beginner, it keeps your hand in for drawing generally. You learn about perspective and the shape of such objects as mountains, trees, rivers and buildings. If you always have a small sketchbook in your pocket, you can pull it out quickly on a walk and jot down something that appeals to you — it may even be a group of figures at a bus stop. You can

learn to draw standing up!

If you make a quick sketch of a subject you are thinking of painting, it will help you to decide whether it is a good composition. As you get more experienced with your painting, you will find you can paint a picture back in the studio from the pencil sketch weeks or years after it was done; I often do.

Figure 3 shows a very attractive old French farmhouse

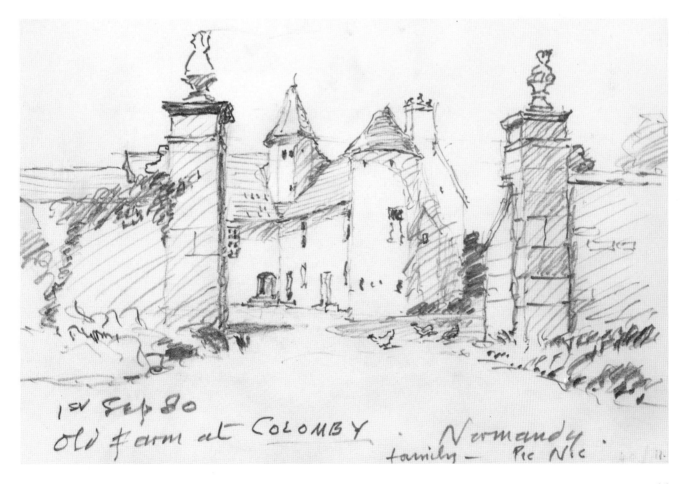

1st Sep 80
Old Farm at COLOMBY . Normandy .
family — Pic Nic

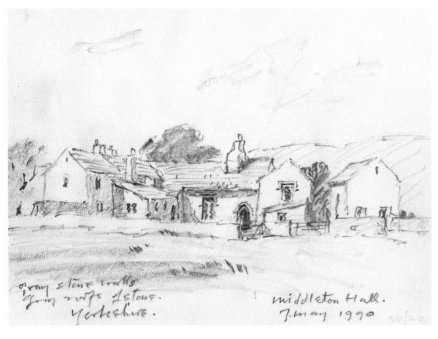

gray stone walls
grey roofs 1 stone.
Yorkshire.

middleton Hall.
7. May 1990

4 *Farmhouse at Middleton, Yorkshire*

sketched some years ago. I was returning home through Normandy with the family, heading north to catch the ferry for England, and we decided on this spot for our picnic lunch. Some of the farms in this area have very beautiful buildings and this one would probably be late seventeenth century. It took me about twenty minutes to draw while munching my French roll and several years later I did a small watercolour painting from it. The colouring was very easy to remember. It was all grey stone with blue-grey slate roofs and a touch of green grass in the foreground. I used a 4B pencil for this sketch. All the pictures in this chapter, including this one, were drawn on ordinary cartridge paper.

Figure 4 shows another stone farmhouse, this time in Yorkshire. I have not yet made a water-colour from this sketch, but one day I will.

I used an A5 sketchbook for these two drawings and I continued to do so for most of the next ones, but for **Figure 5** I used the book upright, getting in two smaller sketches. Last year we were in Cumbria and I did various walks with sketchbook in pocket. Borrowdale is full of lovely walks in unspoilt country, and I will now show you a whole series of good subjects on the Seatoller fells.

The top half of **Figure 5** shows a narrow mountain path with a pleasing group of fir trees on the corner and some rocks and sheep. This took me ten minutes, using a 6B pencil. The sheep studies on the lower half of the page took fifteen minutes, again using a 6B pencil. I know the time as I jotted it on the

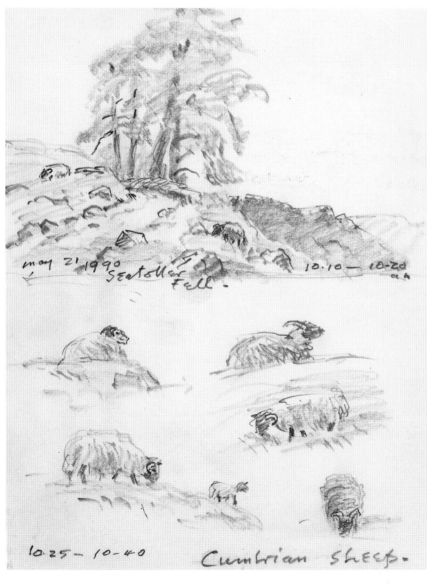

may 21 1990
Seatoller Fell .

10.10 — 10.20 a.m

10.25 — 10.40

Cumbrian sheep.

5 *Seatoller Fells and Sheep, Cumbria*

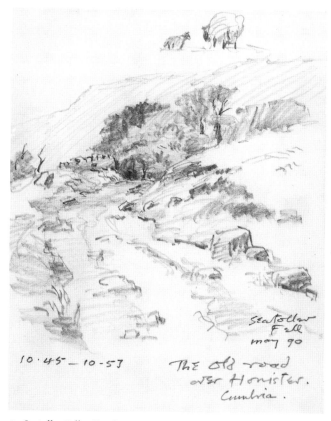

6 *Seatoller Fells, Cumbria*

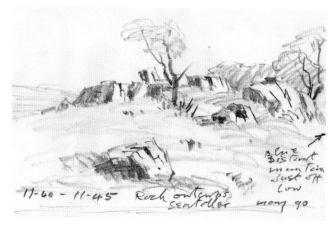

7 *Rocky Outcrop, Seatoller Fells*

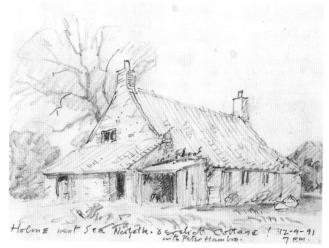

8 *Derelict Cottage, Holme-next-the-Sea, Norfolk*

paper. The sheep studies have been particularly useful for painting in sheep on various pictures.

I do want to encourage you all to make these kinds of sketches. I eventually made quite a nice, very small watercolour of the fir-tree subject.

A little further up, the track in **Figure 5** joins another, slightly wider track, seen in **Figure 6**. Here you can see a lovely little view of a very paintable group of trees, plenty of loose rocks and a mountain outline beyond. When

I reached a higher point on this walk, getting above the treeline, I came across the fine rocky outcrop shown in **Figure 7**. This was a five-minute sketch, again with the 6B. The rocks could be invaluable for reproducing in the foreground of another picture.

Driving along the north Norfolk coast with a painting friend recently, he suddenly

shouted 'Stop!' as we passed an untidy high hedge. He had noticed a ruin! We broke through the hedge and, to our joy, found a gorgeous old empty cottage standing in an overgrown orchard. My sketch, shown in **Figure 8**, was done very quickly as we were late for supper, but I felt I *must* get a record of it for a future painting.

13

9 Two Country Road Scenes, Cotswolds

A few months ago I was cruising around our Cotswold country lanes looking for a suitable place to take a group of painters out sketching. You can see in **Figure 9** the two country-road subjects that I found. They both had grass verges wide enough to allow people to sit or stand and paint. These are the sort of simple subjects that a lot of people would pass by unnoticed, but so often it is the simple subjects that will make a beautiful picture. A 6B pencil was just right for these quick sketches.

On the Isle of Skye on the west coast of Scotland, I made the two rough pencil sketches shown in **Figure 10** and **Figure 11**. I have made notes about the colouring on both of them. Being large views, it is not quite so easy to memorize all the colours, but these brief shorthand notes are all that is wanted for painting a picture in the future.

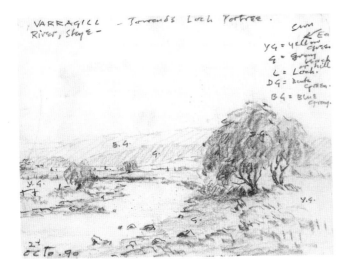

10 Varragill River, Isle of Skye

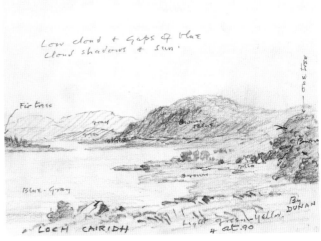

11 Loch Cairidh, Isle of Skye

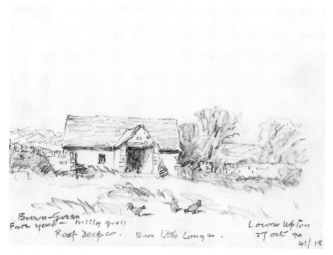

12 *Stone Barn, Lower Upton, Cotswolds*

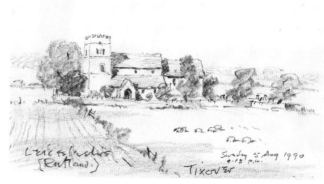

14 *Church, Tixover, Leicestershire*

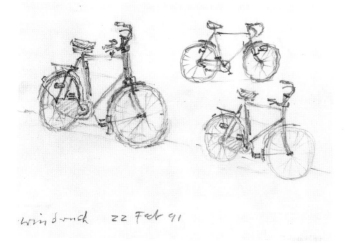

13 *Bicycles at Windrush*

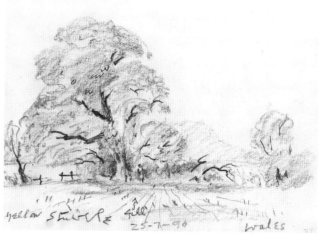

15 *Large Tree in Wales*

A quickly done sketch is shown in **Figure 12**. This Cotswold stone barn is an ideal subject for the beginner. I did eventually make a watercolour from this pencil sketch.

The sketch in **Figure 13** is a quick jotting I put down, as I required some bicycles for a picture of Oxford High Street.

On a family walk in Leicestershire one Sunday in August, we came across the charming country church shown in **Figure 14**. This undoubtedly could make a good watercolour one day.

The same sketchbook contains some Welsh views and I must include **Figure 15**, a study of a very fine tree. My wife Gill is standing at its foot, which gives a good idea of its very large size. A Welsh mountain is indicated in the distant background.

And now for a winter tree sketched at Windrush in March, shown in **Figure 16**. This was on one of my daily walks with the dog. The thick ivy creeper can be seen round the tree trunk, with bare branches above. I always think trees are just as fascinating in winter as in summer.

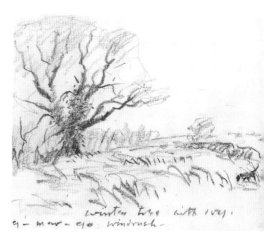

16 *Tree in Winter, Windrush*

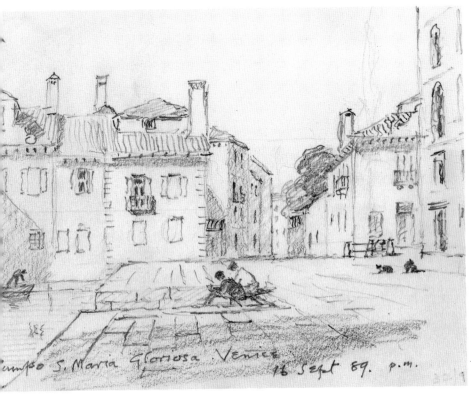

17 *Campo S. Maria Gloriosa, Venice*

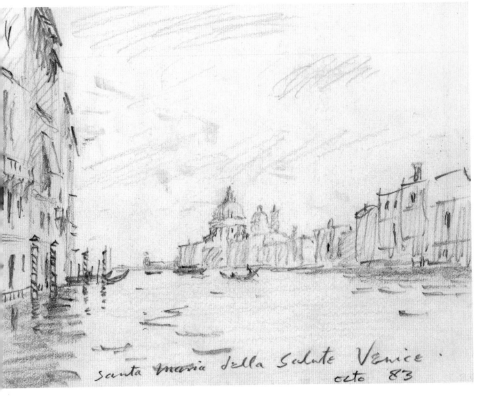

18 *Grand Canal and S. Maria della Salute, Venice*

Away from the English countryside for a moment to Venice in **Figure 17**. Campo S. Maria Gloriosa has little side-canals passing by it, and delightful old two- and three-storeyed houses with red-and-brown-tiled roofs and shutters to the windows. There is enough information in this sketch from which to make a pleasing watercolour. I used a 3B pencil for this drawing as I wanted more detail.

Another Venice sketch, seen in **Figure 18**, shows the Grand Canal with the Salute church, very quickly and roughly done just to remind me of a view to come back to and do a painting.

Changing the scene to Ireland, I had plenty of rain during this visit in 1988 but the colours were fantastic. The very rough sketch shown in **Figure 19** was made in a hurry as my son Charles and I were due at a place further on. The light was so startling that it had to be recorded, however quickly and badly.

The Twelve Pins, Connemara, shown in **Figure 20**, was done on a wet day in about eight minutes from inside the car. A little later Charles and I decided to sit outside and risk doing a painting, and we both managed to do a quick one with dramatic skies before it rained again.

One more Irish sketch, shown in **Figure 21**, was a delightful subject and it made a very pleasing watercolour, painted after I got home.

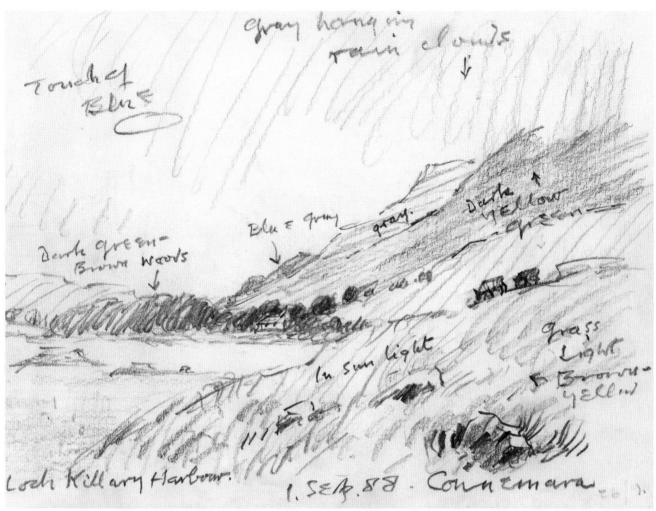

19 *Rainclouds and Sunshine, Connemara*

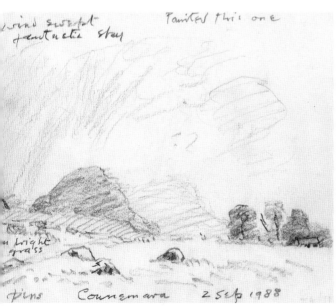

20 *The Twelve Pins, Connemara*

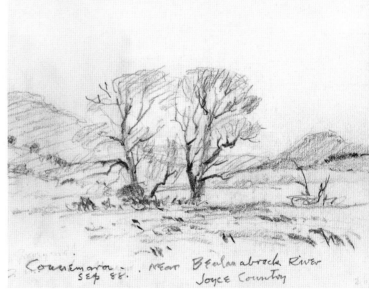

21 *Trees, Connemara*

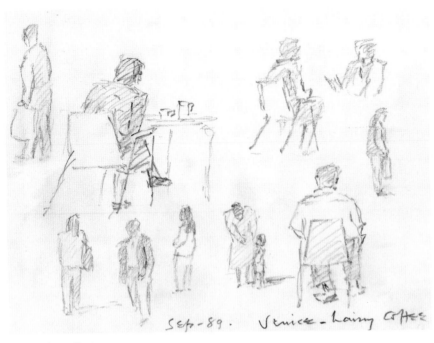

22 *Coffee in Venice*

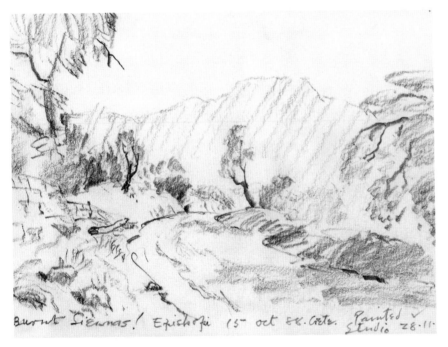

23 *Mountain Road at Episkopi, Crete*

In **Figure 22** are a few figures on a typical page from a Venice sketchbook. I was having a coffee break while I sat and did my drawing.

A very paintable part of the world is the island of Crete. **Figure 23** shows a dusty mountain road at Episkopi. Lots of *Burnt Sienna* was required when I eventually made a watercolour of this subject from the pencil sketch.

Again in Crete, the hill village of Krista in **Figure 24** was a real treat to paint. I made this pencil drawing in a larger sketchbook (19 cm × 24 cm; 7¾ in × 9¾ in), with a view to painting it later. We were on a day's coach trip and there was not time for painting.

The Cotswolds always look extremely attractive after a heavy fall of snow and **Figure 25** was made in the winter of 1990 when we had quite a lot of snow. Painting in the snow is always cold work and most of my snow pictures are done from pencil drawings like this one. I used a 6B pencil for most of this sketch, but a 3B for the small detail of the farmhouse and barn.

Figure 26 shows a sketch of the lovely Regency façade of Boodles Club in St James's, London. One day I mean to do a watercolour from this sketch. It is not easy to do watercolour paintings on the spot in London because of the crowds and heavy traffic.

I have tried to give you a good variety of subject matter in the pencil sketches for this chapter in the hope that you will learn by constant practice to be versatile and not to be afraid to tackle anything.

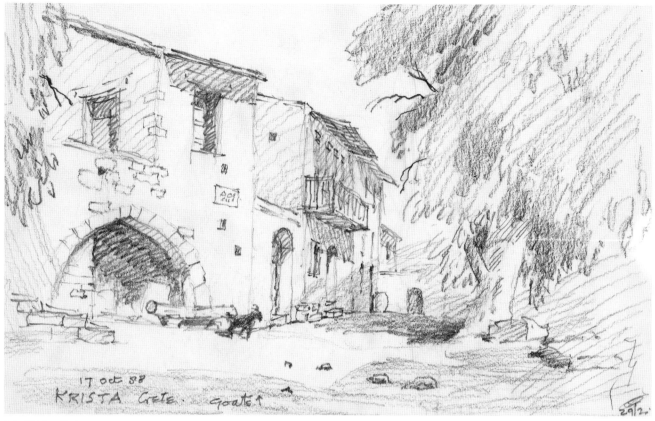

24 *Krista, Crete*

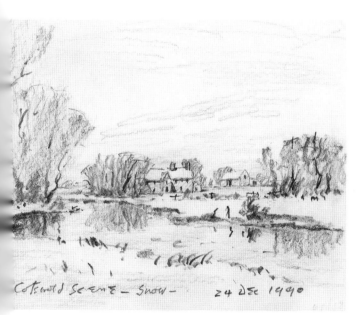

25 *Cotswold Scene in Snow*

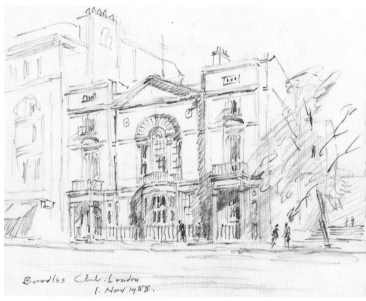

26 *Boodles Club, St James's*

3

THE COTSWOLDS

Country lanes and distant views, Cotswold stone barns, cottages and houses, a stream, a fallen tree in snow, Oxford in snow

COTSWOLD country includes Oxfordshire and Gloucestershire, and these areas lie in the great limestone belt which runs across England from the Severn Valley in the south-west to the Wash in the north-east. The stone gets darker as it goes north, and in the Cotswolds it is a very lovely light honey colour, which is why the Cotswold towns and villages are so much admired.

Several country buildings are shown in this chapter and very paintable they are, as you will see. But first I will start with some open-country scenes.

Figure 27 *Country Road, Cotswolds* is a delightful subject only a mile or two from Windrush, painted on the spot in autumn. Thank goodness there are still plenty of little roads like this left, in spite of modern traffic. The edges of the road are broken and irregular along the rough grass verges; long may they remain so.

This was a late-afternoon painting, giving long shadows from the trees across the road. In the far distance are the Berkshire Downs. The main feature of the picture is the oak tree with its

27 *Country Road, Cotswolds.*
317 mm × 476 mm (12½ in × 18¾ in)

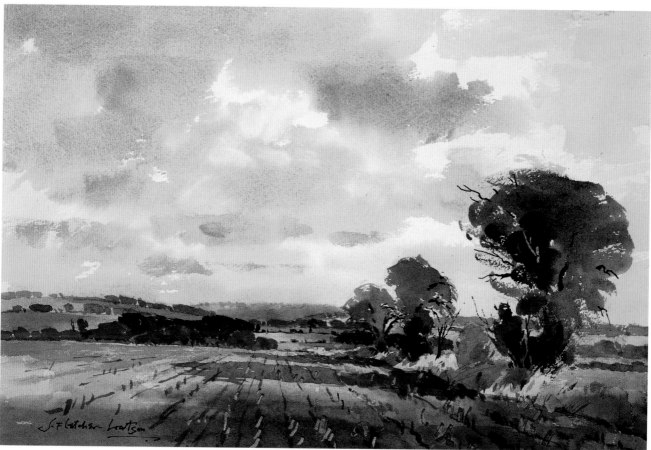

28 *Windrush Valley, View across Stubble.* 317 mm × 476 mm (12½ in × 18¾ in)

leaves beginning to fall, leaving bare branches showing in places. The foliage colour is a mixture of *Burnt Sienna* and *Burnt Umber*. This is certainly one of my favourite trees seen at this state of change from autumn to winter.

Another picture of open country is shown in **Figure 28** *Windrush Valley, View across Stubble*. This view is looking slightly downhill and the three small trees on the right are a great help in giving perspective and distance, as are the lines of stubble in the foreground. The sky does the same thing, the patches of blue getting smaller towards the horizon. Note also that the strength of colour on various features gets weaker as they recede into the distance. The shadow in the foreground has a blurred, soft edge which denotes it is a cloud shadow, whereas the two shadows beyond have hard, sharp edges because they are tree shadows.

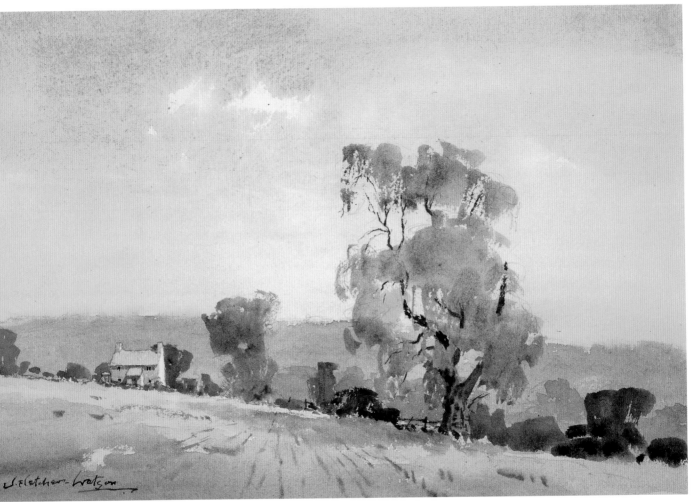

29 *Early Morning, Windrush.* 317 mm × 476 mm (12½ in × 18¾ in)

Figure 29 *Early Morning, Windrush* is a good example of simplification in painting. It is a series of washes without detail. In the early morning light, everything was reduced almost to silhouette. Of particular importance is the handling of the large ash tree on the right. For the foliage, I mixed *Raw Sienna* and a small amount of *Winsor Blue* and *Burnt Umber*, without too much water in the mix. I used my large no. 6 squirrel mop brush and, with the brush held sideways, dragged it downwards in quick strokes, starting at the top. Having obtained the shapes I wanted, I painted in the trunk and branches with a small brush, using a dark brown mixture, while the foliage was still damp.

That is all I am going to say about this picture as I want to leave you with this one thought – simplification.

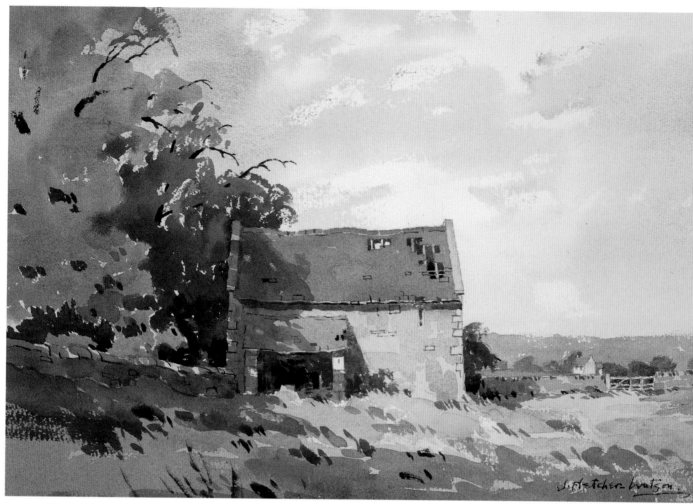

30 *Small Barn, Windrush.* 317 mm × 476 mm (12½ in × 18¾ in)

The Cotswold countryside is full of large and small stone barns. Most of these are several hundred years old, and they are usually of attractive proportions. **Figure 30** *Small Barn, Windrush* is a typical example. You can see what a good composition this is: the block of high chestnut trees on the left holds the barn in the picture, and the ground falling away to the right with the distant blue-grey hill gives a feeling of infinite space. The rough grass in the foreground gives a nice texture, and of course the key to the composition is the lovely dark door opening in the lean-to structure. Shadows from the trees on the roof and foreground are invaluable in giving life to the landscape. This picture is featured in a video, *The Magic of Watercolour,* which has been made of me painting the subject out of doors; I go through the motions from beginning to end. It can be obtained from me at Windrush (see page 4 for details).

Figure 31 *Large Barn at Taynton, Oxfordshire* is part of a large group of farm buildings and a fine stone farmhouse. Before doing this painting I made several quick pencil sketches, one of which is shown in **Figure 32**, which is the opposite side of the barn. This took about ten minutes. I eventually settled for the view shown in **Figure 31** as the shadows were better. The sloping ground added to the attraction of this architectural composition and, as in the case of the small barn, the great open doorway with its dark interior made a splendid focal point. A subject like this is full of detail and it can only be made to hold together by leaving out some of the detail. For instance, the interior of the large lean-to shed on the left was deliberately given an unfinished appearance and the foreground-grass treatment was kept as simple as possible.

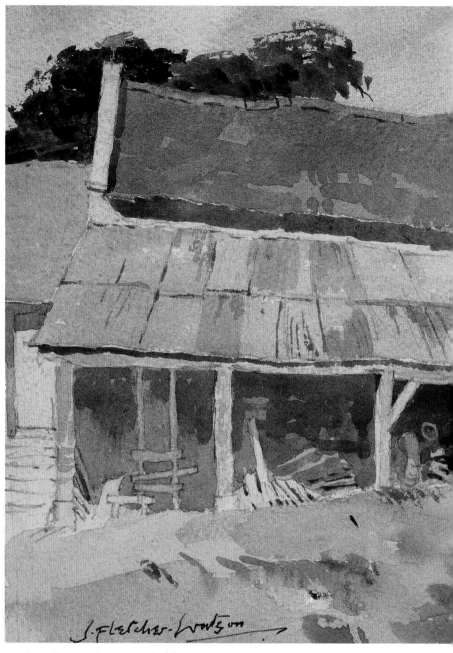

31 *Large Barn at Taynton, Oxfordshire.* 242 mm × 476 mm (9½ in × 18¾ in)

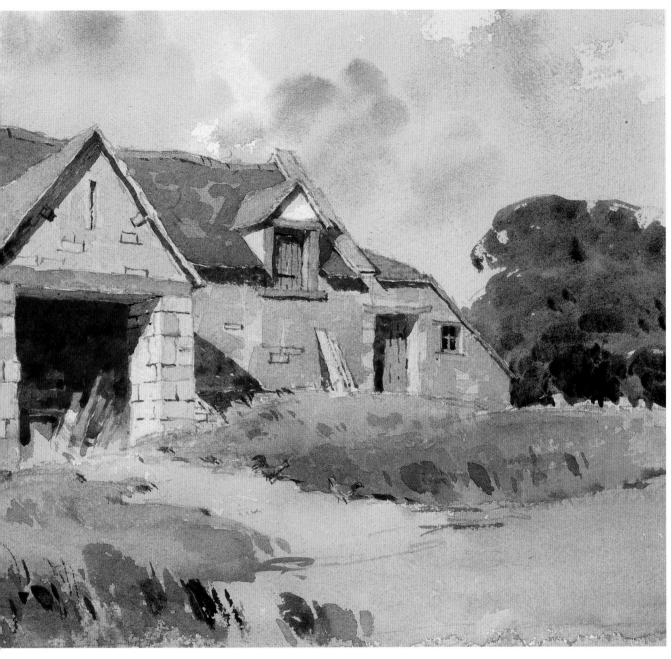

32 *Large Barn at Taynton, Oxfordshire*

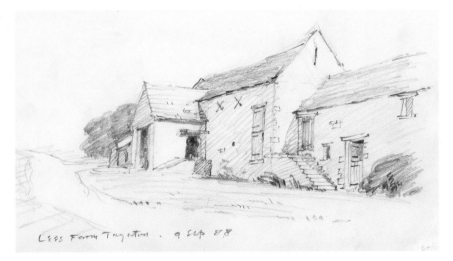

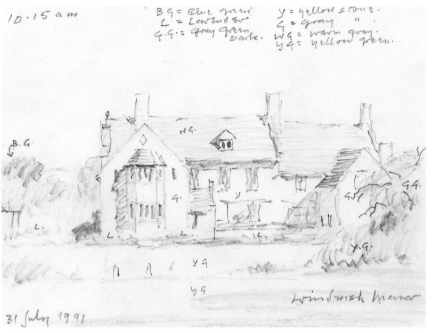

33 *Windrush Manor*

I do not often take on commissions to paint people's houses, but **Figure 34** *Windrush Manor* was an exception as I particularly like the old house. It was a surprise present from husband to wife so I was asked to be as short a time in the garden as possible. I made a careful drawing on the spot on the full-size piece of watercolour paper which was to be the final painting; this did not take long. I then made a quick pencil sketch in a small sketchbook, shown in **Figure 33**, marking the essential colours which would be my *aide-memoire* in the studio, where I would actually paint the picture. I find I can imagine the colours much better looking at a rough sketch than looking at a colour photograph.

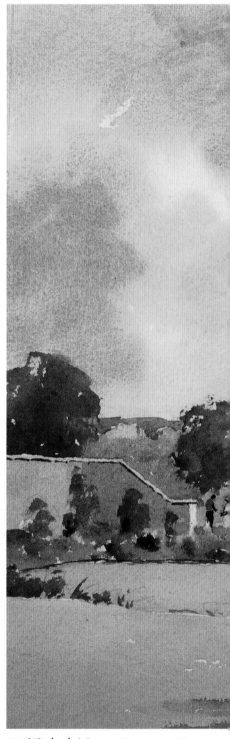

34 *Windrush Manor.* 317 mm × 476 mm (12½ in × 18¾ in)

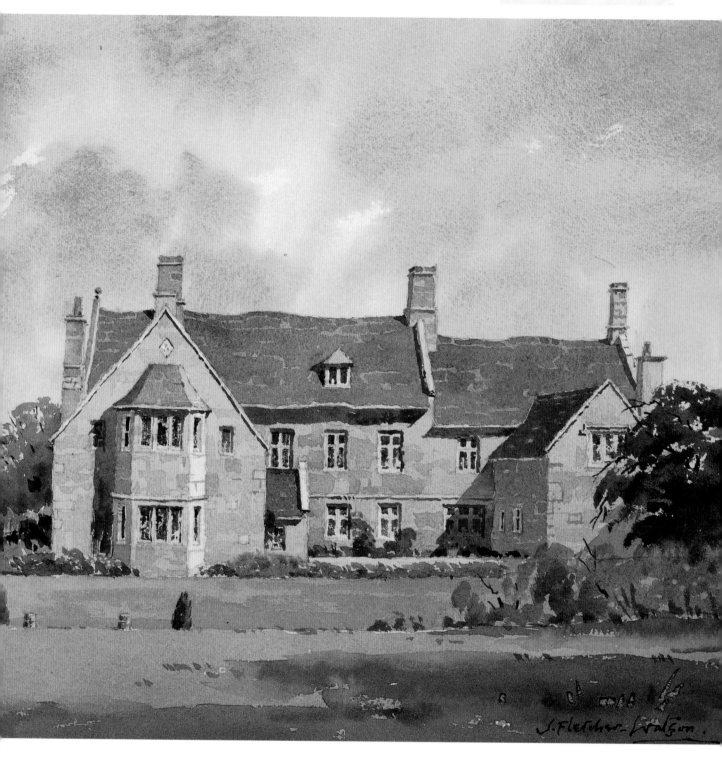

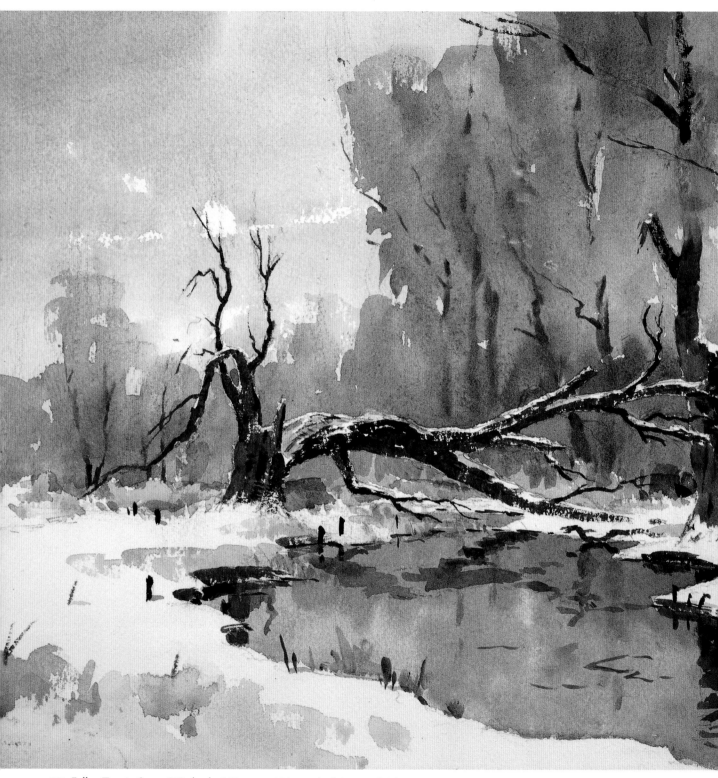

35 *Fallen Tree in Snow, Windrush.* 317 mm × 476 mm (12½ in × 18¾ in)

Now we will look at a very different sort of picture, in **Figure 35** *Fallen Tree in Snow, Windrush*. This occurred in the heavy gales we had in January 1990 and I could not resist having a go at such a dramatic subject. I was quite fond of this tree as I had sketched it before. At first I was sorry it had fallen but then I realized what a marvellous picture it would make. It was too cold to paint out of doors and it was a long tramp from home, so I made a pencil sketch, seen in **Figure 36**, and painted from this in the studio. I will give you the details of how this picture was painted.

The paper I used was Winsor and Newton artists' watercolour

28

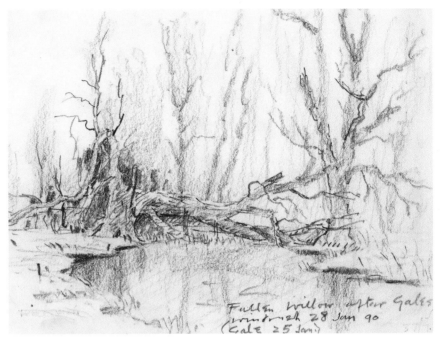

36 *Fallen Tree in Snow, Windrush*

left than in my pencil sketch. This is legitimate artist's licence, to improve the composition. The stream is a tributary joining the River Windrush and the fallen tree reached right across it. I drew in the tree rather carefully and firmly as I needed to leave white paper for the snow along the trunk and branches when it came to painting.

I first painted the sky, using *Cobalt Blue* on an already dampened paper and allowing the colour to run and form white clouds. I took this wash right over the wooded areas but left one or two places where I remembered that snow had lodged on the tree branches.

The next stage was quite simply to block in the brown woods, making them fade into the sky in places by adding a touch of clear water. I used *Burnt Umber* mixed with *French Ultramarine* for these washes. I painted very carefully round the fallen trunk and its branches, leaving them all white. While the brown wash was still damp, I quickly painted in the various trunks of the distant trees with a

smaller brush (about a no. 5), so that they were blurred and not too clear-cut.

Now I could paint the fallen tree itself, using nos. 5 and 3 brushes and a strong stiff mixture of *Burnt Umber* and *French Ultramarine*. The mixture was very dry at times (I dabbed the brush on a towel to achieve this) and I was able to leave a rough edge against the snow-covered areas. I next painted the large standing tree on the right, using the same brown colour as for the fallen tree.

At this point I had to paint the blue-grey areas of the lower parts of the wood, merging the wash by damping with clear water first, then painting carefully up to but not on to the white snow-clad branches of the fallen tree; this helped show up the white snow most effectively.

I could now tackle the water. First the banks were given a strong dark brown edge of earth showing horizontally below the snow covering, painted with a no. 7 brush in appropriate places. Then I used the same-size brush to paint a few dead grasses on

paper, 260 lb Rough. It has a nice texture for a snow picture and it is also easy to draw on. I used a 2B pencil. First I lightly sketched in the line of the stream and the shape of the wood behind, showing rather more sky to the

29

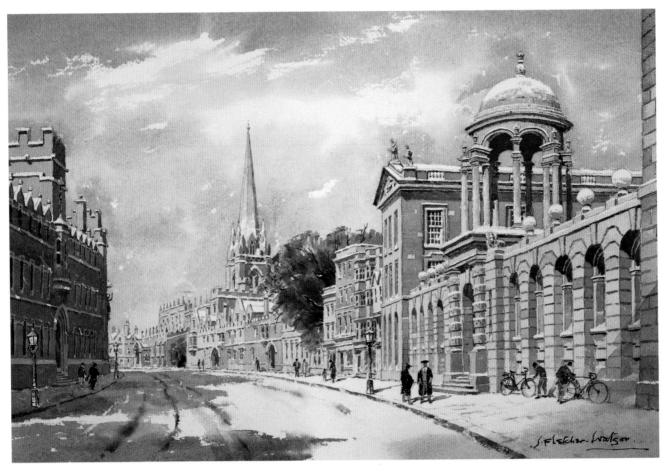

37 *The High, Oxford, in Snow.* 317 mm × 476 mm (12½ in × 18¾ in)

the right bank in *Raw Umber*. With a smaller brush, I painted some vertical sticks and stumps near the water's edge. Now a flat wash was required all over the water, of well-diluted *Payne's Gray* with a touch of *Raw Sienna* mixed in. As this dried a little, I washed in the light brown-grey reflections of the background woods and then some stronger brown-grey tree-trunk reflections.

The final job was to paint in blue-grey shadows on the snow, using a mixture of *French Ultramarine* and *Light Red*.

Only seven colours were needed for this picture: *Raw Sienna, Raw Umber, Burnt Umber, Light Red, Cobalt Blue, French Ultramarine* and *Payne's Gray*.

The pencil sketch in **Figure 36** measures 140 mm × 205 mm (5¾ in × 7¾ in). It gave me ample

information for painting the 317 mm × 476 mm (12½ in × 18¾ in) watercolour. I did not write any colour notes on the pencil sketch; I painted this picture the same day as I did the pencil sketch, so the colouring was quite fresh in my mind.

Figure 37 *The High, Oxford, in Snow* is one of the most highly detailed architectural subjects I am showing in this book. It is an irresistible subject because the many buildings in it are all of them good architecture; there is not a single ugly building amongst them. It is a daunting subject, but the trick to learn is how to leave out detail and still retain the impression of rich architecture.

I used Whatman Not paper and did quite a lot of drawing with a B pencil before starting to paint. I had a copy of a previous drawing I had made of this view, which helped speed up the preparation work. This street is always packed with traffic and this was one of the few occasions when I used a photograph.

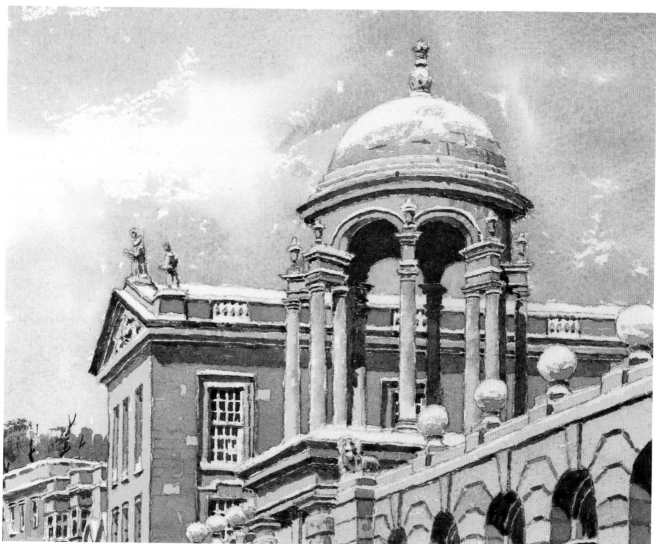

38 Detail of Figure 37

If you look at the enlarged detail in **Figure 38**, you will see some of the pencil work and the simple paint work indicating mouldings, windows, shadows, etc. All the white snow was obtained by leaving the white paper, not by adding white paint.

4

SCOTLAND

*Mountains, lochs, low cloud, stormy weather,
painting from the car*

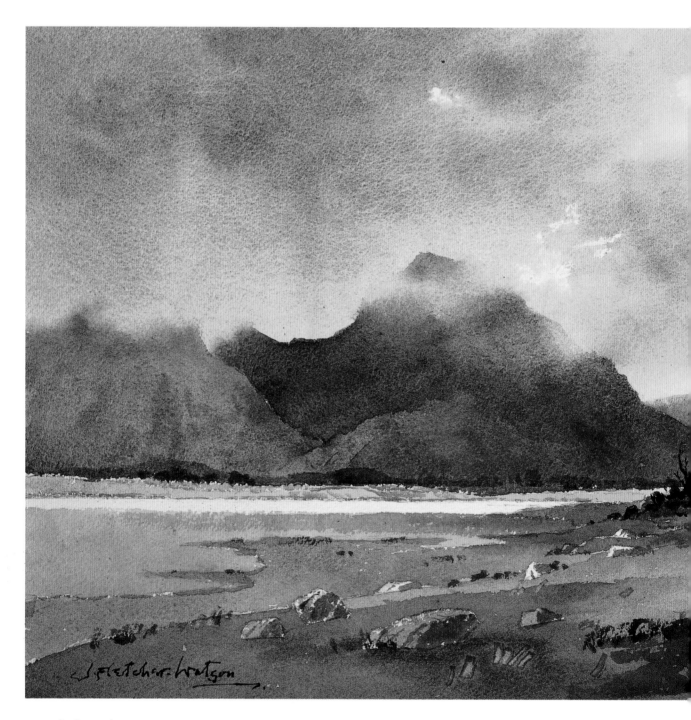

39 *Loch Slapin, Skye.* 317 mm × 476 mm (12½ in × 18¾ in)

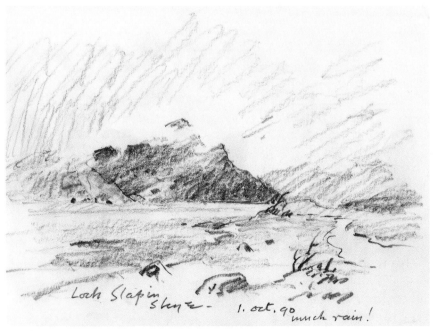

ON the island of Skye on the west coast of Scotland in the autumn of 1990 it poured with rain for weeks and weeks, but I was determined not to be daunted. Gill and I bravely set forth each day with our map, picnic lunch and lots of hot coffee. The golfers and fishermen stayed in the hotel as the golfcourses were flooded and the rivers in spate, but they did not know the secret of painting from inside a car!

After many miles of rough road into southern Skye, we found the magnificent view shown in **Figure 39** *Loch Slapin*. Low cloud and mist were constantly hiding the mountain ranges, then up it would go, revealing the whole landscape, and sometimes there would be a ray of sunshine.

Having got the car into a good position beside the road (for it *had* to be a car painting), I made a quick pencil sketch, shown in **Figure 40**, just in case the clouds decided to stay down and hide the scene for the rest of the day. I used the A5 size of sketchbook and a 5B pencil.

Looking at the colour illustration, you will see what a very perfect subject this is. Using a sheet of Whatman Rough paper and a 2B pencil, I first drew in the base line of the mountain at the far side of the loch. This was about one third the way up the sheet of paper. I then sketched in the outline of the mountain ranges, the jagged edge of the loch in the foreground, the road and the various rocks. This did not take long and I could now get straight on with the painting.

Sitting in the passenger front seat, I had my board on my knees with the top resting against the dashboard. Paintbox and water jar were on the improvised shelf between the front seats, and brushes were close to my right hand on a towel on the driving seat.

It will not be necessary to tell old hands that before coming out I had softened all the colours in my paintbox with hot water and a stiff oil-painting brush, but some of you less-experienced painters may not know about this important procedure. You cannot work fast with watercolours if your colours are hard and stiff; they must be soft and fluid and when necessary pans should be replenished with fresh paint from tubes.

The sky was to be tackled first so I covered the whole area with clear water, but only damping it,

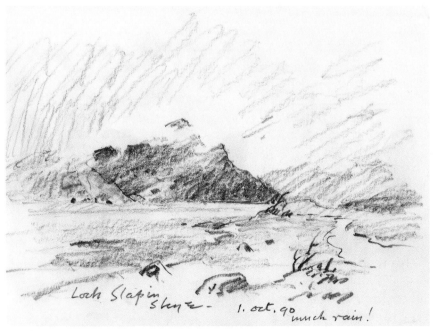

40 *Loch Slapin, Skye*

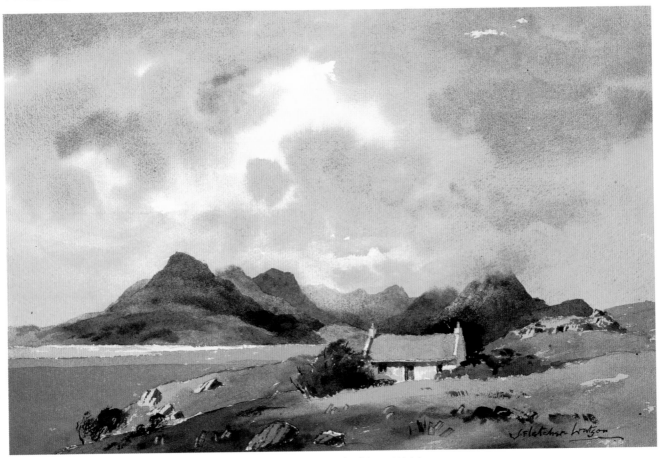

41 *Loch Scavaig and the Cuillin Mountains, Skye.* 317 mm × 476 mm (12½ in × 18¾ in)

not flooding it. I mixed a nice warm grey with *Burnt Umber* and *French Ultramarine* and, using a no. 10 brush, I washed all over the sky, leaving a white patch at the top right-hand corner. I took the wash right down to the line of the loch, making it slightly lighter as I went down by adding clear water. I then touched in *Cobalt Blue* where I had left white cloud in the top right-hand corner. While the grey wash was still damp, I quickly darkened the grey with the same two colours and went over some areas, giving cloud outlines which merged nicely into the first wash. A lot of people go wrong doing this because they get the second wash *much too wet*; it has got to be a fairly stiff mixture. With the aid of the car heater, I got the sky completely dry.

Next I painted in the distant right-hand mountain using *Cobalt*

Blue and *Light Red* for the grey. The cloud coming over the top of this mountain was created by making the top of the mountain damp with clear water and a small (no. 5) brush. The operative word is 'damp', not too much water. You then paint the grey wash up into the damp area and let it blur gently.

I repeated this process for the main range of high mountains, using *Burnt Umber* and *French Ultramarine*. I let the brown dominate for most of the wash, but kept the high peak and the sharp edge to the left a darker blue-grey by making the ultramarine dominate the mixture. I dealt with the low cloud over the mountain top in the same way as on the right-hand mountain.

This work with the mountains and sky is the most important part of the painting, and I would

not advise you to try this sort of subject without having done some practice in the studio first.

When the mountain painting was quite dry, I could proceed with the remainder of the picture. I painted a thin line of light yellow on the far side of the loch, using *Raw Sienna* and the no. 5 brush, and extended this to the right as a light green by adding a small touch of *Winsor Blue*. The little hillock is included in this wash.

Next I painted the muddy, stony foreshore along the near side of the loch, using a mixture of *Burnt Sienna* and *Cobalt Blue*. The green grass in the foreground was a mixture of *Winsor Blue*, *Cadmium Yellow*, and a little *Burnt Umber* to take off the sharpness of the green. This wash included both sides of the road. I painted round the rocks, leaving them white.

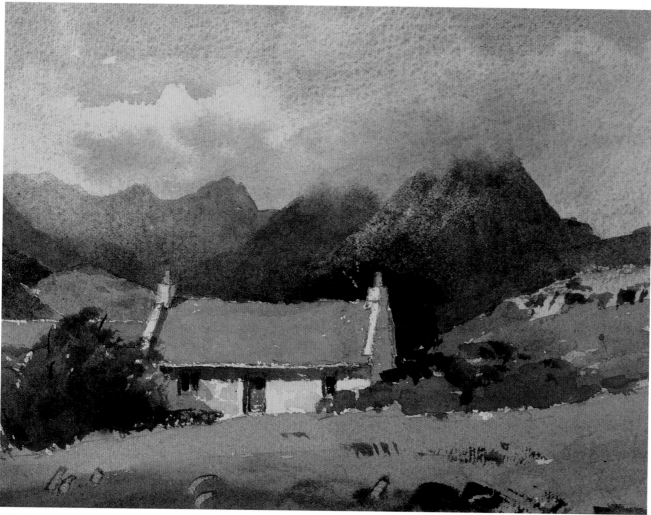

42 Detail of Figure 41

While this wash was drying, I painted a stronger, darker green over the foreground, giving a cloud-shadow effect; I left the more distant grass in sunlight. The shadows on the rocks were painted next with a small brush, using a mixture of *French Ultramarine, Light Red* and a touch of *Raw Sienna*, quite strongly applied.

It only remained for the small bush in the middle distance and the foreground scrub and twigs to be painted, using *Burnt Sienna* and *Winsor Blue*. A few dark edges were added to the grass verges of the road, using the same mixture, and the picture was almost finished.

Finally the water was painted with two coats of *Payne's Gray*,

one medium tone and one darker tone, leaving a white streak where the sun was catching the water on the far side.

This picture took two hours to paint and the colours used were:

1 *Cadmium Yellow*, 2 *Raw Sienna*, 3 *Burnt Sienna*, 4 *Burnt Umber*, 5 *Light Red*, 6 *Cobalt Blue*, 7 *French Ultramarine*, 8 *Winsor Blue*, 9 *Payne's Gray*.

I have said it before but I will say it again — watercolours should be painted *fast*, not slowly, because you don't want to dawdle and fuss the picture with unnecessary detail. However you must not start too soon. Do some very careful thinking before you commit brush to paper. Have you got the composition right?

Where do you want your darkest dark and your lightest light to be? How much detail in the foreground will you leave out? In fact, paint with your head and not just with your hand.

Driving along the same rough little road in Skye, going further west, we came to a dead end and the remote hamlet of Elgol. Perched on the cliff above was a crofter's cottage and the stunning view shown in **Figure 41** *Loch Scavaig and the Cuillin Mountains*. This was not on the same day as the previous painting and it had not actually rained for two hours or so. The clouds were a little higher, just touching the right-hand peak, and it was an attractive sky with several good patches of blue.

Loch Slapin Skye · 1. oct. 90 much rain!

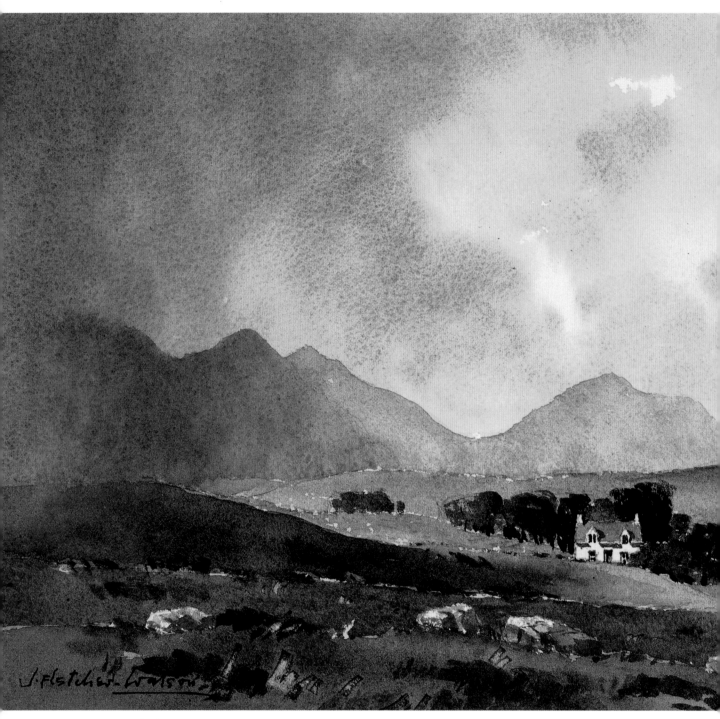

43 *Cottage near Elgol, Skye.* 235 mm × 355 mm (9¼ in × 14 in)

I walked about a bit choosing my viewpoint; it was easy to get the cottage nicely to the right, with the counterbalancing high mountain on the left. I painted quickly with the minimum of detail and simple washes. I gave a lot of thought to tone values, especially for the mountain range in the background.

To help you see the painting, I have included an enlarged detail in **Figure 42**. Note the soft edges of the mountains, which give distance; and also the dark bushy tree behind the right-hand end of the cottage: this gave the contrast I needed to show up the white-washed cottage standing in brilliant sun.

44 *River Varragill, Skye*

Driving back in the afternoon of the same day, the weather became stormy and we caught sight of an exciting view with curtains of rain and glimpses of sun, shown in **Figure 43** *Cottage near Elgol.* This was most dramatic and I had to stop and do a quick small watercolour from under cover inside the car.

Skye abounds in subjects and I filled a sketchbook with pencil sketches that would be useful when I got back to my studio in the Cotswolds. **Figure 44** *River Varragill* was one of many river views that I noted. I wrote various notes on this sketch to tell me all I wanted to know for making a painting.

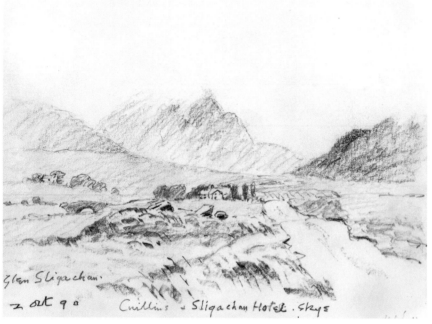

45 *The Cuillins, Skye*

Figure 45 *The Cuillins*, with Sligachan Hotel in the trees and a stone road bridge on the left, was another pencil sketch done during pouring rain from the car. The clouds kept moving down and hiding the view, then lifting again. I eventually painted a good watercolour of this subject.

After a week, we moved from Skye to Inverness-shire, staying with friends for a few days and discovering parts of Scotland we had never seen before. **Figure 46** *Glen Affrick* was a particularly beautiful glen and there was snow on the distant mountains which added to the charm. This was typical Scotland with a loch, a rough stony road, rocks in the foreground, and various tree groups and woods, and the brown autumn colouring made it superb.

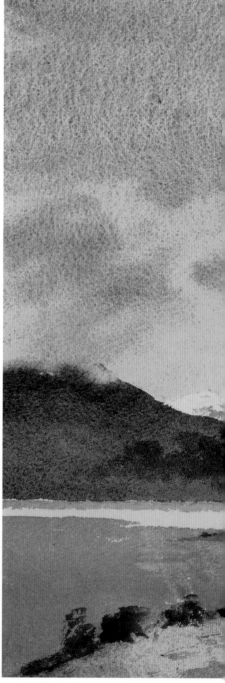

46 *Glen Affrick, Inverness-shire.*
317 mm × 476 mm ($12\frac{1}{2}$ in × $18\frac{3}{4}$ in)

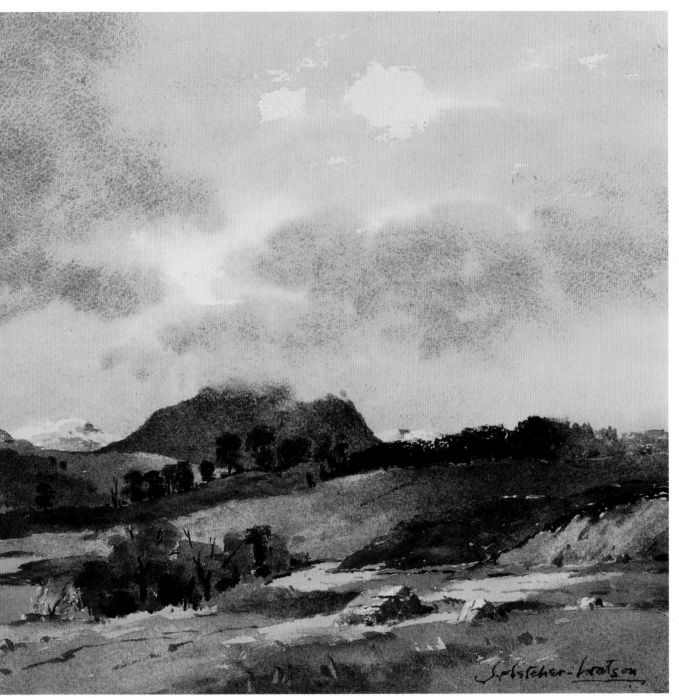

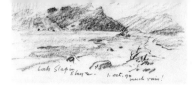

47 *Strathglass, Inverness-shire*

Returning from a day's painting one late afternoon, we were on a single-track road that had lovely views all the way along. Although it was after 6 pm, I had to stop and do a quick pencil sketch, shown in **Figure 47**. I also quickly jotted down one or two colour notes. Later on at home, I made the small watercolour painting seen in **Figure 48** *Strathglass, Inverness-shire*. There was an all-pervading autumn colour to the trees, bracken and grass; I used mostly *Raw Umber* with a small amount of *Winsor Blue* and *Burnt Sienna*. *Raw Umber* is a very useful colour as it saves you using *Raw Sienna* all the time and darkening it with *Burnt Umber*.

48 *Strathglass, Inverness-shire.*
235 mm × 355 mm (9¼ in × 14 in)

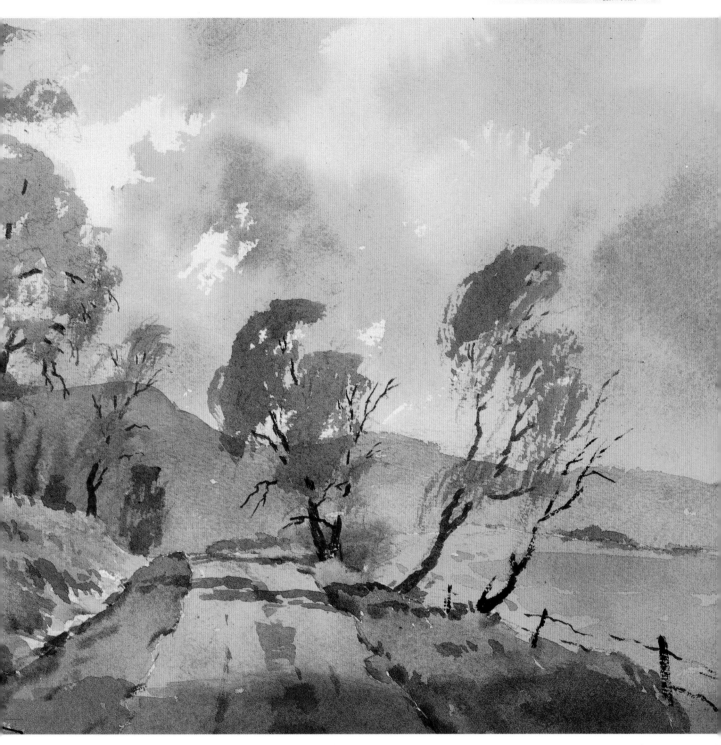

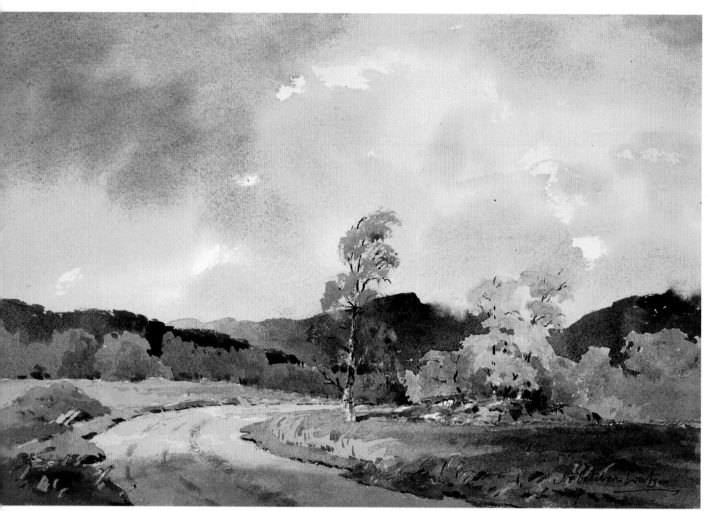

49 *Glen Strathfarrar, Inverness-shire.* 317 mm × 476 mm (12½ in × 18¾ in)

Another gorgeous valley is shown in **Figure 49** *Glen Strathfarrar*, also in Inverness-shire. The colouring was a real treat, with *Raw Umber* and *Burnt Sienna* everywhere. The great feature in this glen was the silver birch trees with their white trunks. I had to take a little care painting round these trunks, but they were great fun to do.

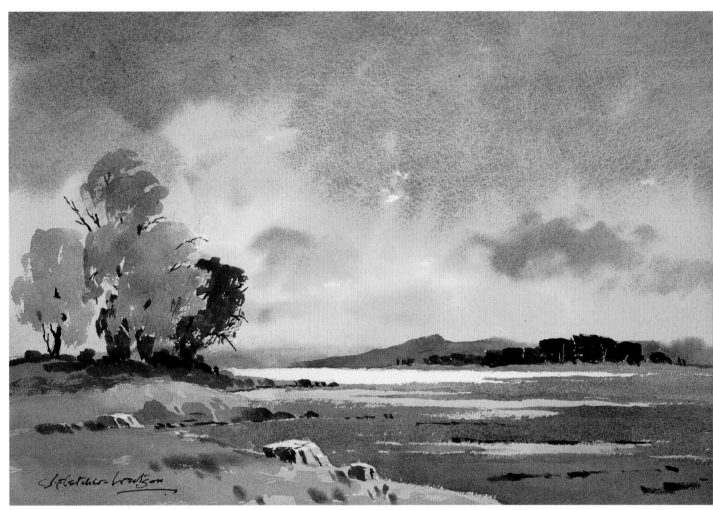

50 *The Beauly Firth, Inverness-shire.* 317 mm × 476 mm (12½ in × 18¾ in)

Finally I show you **Figure 50** *The Beauly Firth*. This peaceful estuary, where you can hear the call of many seabirds, leads into the Moray Firth and away to the North Sea. I felt I was miles from anywhere. This was a lovely contrast to the mountain country and the group of silver birch trees on the left made a good composition.

Scotland is a place full of atmospheric drama and I hope I have captured some of it in these pictures. It is a great place for the watercolour painter.

5

NORFOLK

Windmills, big skies, marshes, fishermen's cottages

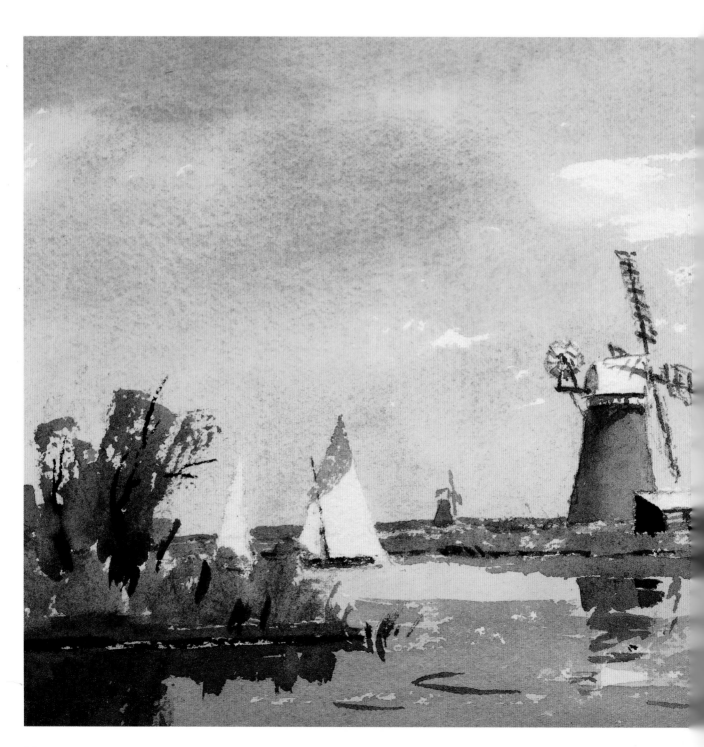

NORFOLK has a great attraction for painters with its large skies and open landscapes.

Figure 51 *On the Thurne* shows a typical Norfolk view painted on an autumn day of lovely colouring. This is on the Broads, to the north-east, and I can highly recommend this area for artists. It is only a small painting, measuring 14 cm × 19 cm

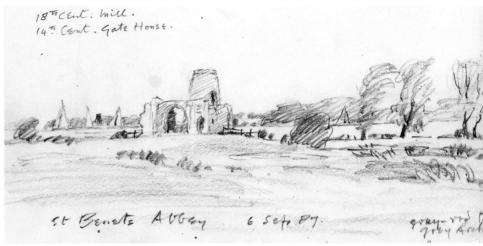

52 *St Benet's Abbey, Norfolk*

($5\frac{1}{2}$ in × $7\frac{3}{4}$ in), but they can be just as attractive as large ones.

Not far away is a delightful subject, seen in **Figure 52** *St Benet's Abbey*. It was a very cold day so I made a twenty-minute pencil sketch. It was not difficult to make a painting from the sketch; all I had to remember was that the windmill tower is mellow red brick, and the building with the arch is grey stone with a little brickwork in places. This ruin is on the banks of the River Bure, and you can see sails of boats in the distance.

Going on to the north Norfolk coast, there is a famous town, shown in **Figure 53** *Cromer*. If you walk along the top of the high cliffs, there is a whole series of good views. I made a quick sketch of this excellent view in my small sketchbook. The sandy cliffs make a lovely foreground, with the church tower and town beyond – a good subject for a future painting.

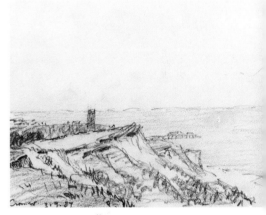

53 *Cromer, Norfolk*

51 *On the Thurne, Norfolk.* 140 mm × 197 mm ($5\frac{1}{2}$ in × $7\frac{3}{4}$ in)

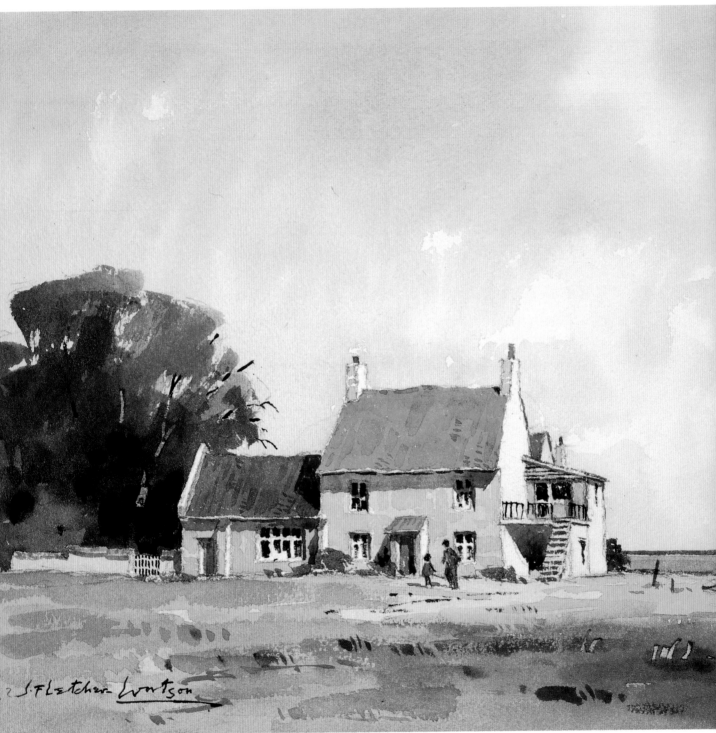

54 *Fisherman's Cottage, Titchwell, Norfolk.* 317 mm × 476 mm (12$\frac{1}{2}$ in × 18$\frac{3}{4}$ in)

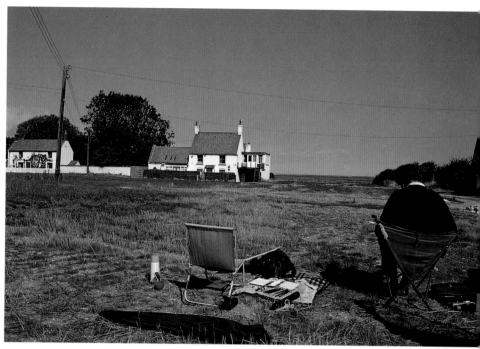

55 Photograph of view painted in Figure 54

The subject for **Figure 54** *Fisherman's Cottage, Titchwell* was found some way westwards along the coast. A painter friend discovered it and we both felt we must paint it.

Figure 55 shows the actual view and my friend Peter hard at work painting. We felt that the second left-hand cottage spoilt the composition so we left it out. A further artist's licence was to omit the wooden fence in front, and to improve the flat-roofed building by giving it a sloping roof! We also left out the overhead cables and posts.

I will now describe the painting operation. I selected a piece of Whatman Rough paper, the whiteness of which was eminently suitable for a white cottage. The composition was excellent, with the trees and cottage to the left and the distant view of the sea to the right. I drew all this in with a B pencil and then started work on the painting. The halfway stage can be seen overleaf.

Having dampened the sky area, I washed this in with the squirrel brush, using *Cobalt Blue*. The few white clouds were created as the wash came down. I lightened the blue towards the horizon and touched in a little *Raw Sienna*. When this was dry, I went straight for the cottage, using *Burnt Sienna* for the main roof and adding some *Burnt Umber* for the lower roof.

Next all the windows and doors were painted using *Burnt Umber* and *French Ultramarine*, as were the steps and balcony. Finally all the shadows went in with *Cobalt Blue, Light Red* and *Raw Sienna*.

Now for the large tree group on the left, in September a lovely warm green. I mixed *Cadmium Yellow, Winsor Blue* and *Burnt Umber* and applied the wash with a no. 10 brush. As this dried I mixed these colours a little darker, adding more *Burnt Umber*, and placed this in the lower part of the trees to give a sharp edge against the roof and the top of the garden wall. I painted the background to the picket gate with this colour, using a small brush. I also painted the two

47

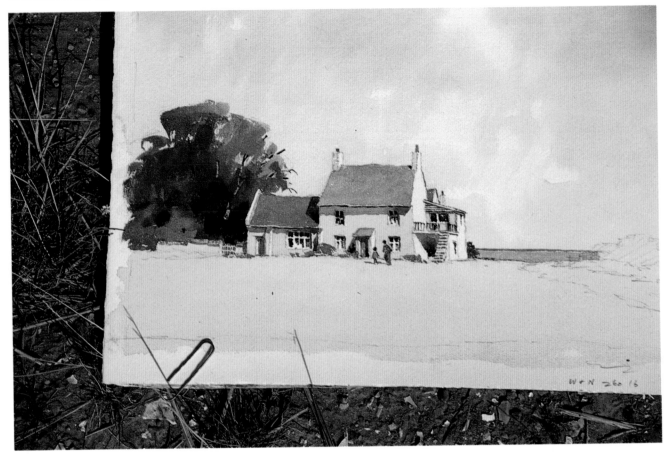

56 Halfway stage of painting Figure 54

figures with dark brown and *Cerulean Blue* for the child.

Next I wanted the distant sea in. This consisted of a thin line of not-too-strong *Payne's Gray*, and below that a well-diluted mixture of *Burnt Sienna* and *Cobalt Blue* for the strip of sand.

We have now reached just over the halfway stage, which you can see in **Figure 56**. I could now draw in with a brush the dark brown edges of the track on the right, followed by the late-summer yellow-green grass on both sides of the track and all over the foreground. I used *Raw Sienna* and *Cobalt Blue* for this wash, but I did leave an area near

the cottage untouched as this was bare earth and rather light in colour. This and the track were painted a very light *Burnt Umber*. I added some touches of *Rose Madder* in the right foreground. It was then time to deal with the gorse bushes above the track, using the same mixture as for the trees.

The foreground having dried, I could paint a light cloud shadow caused by the transparent white clouds. This consisted of a wash of *Cobalt Blue*, *Light Red* and *Raw Umber*. I added some quite dark tufts of grass, using the same three colours, and also a few scratches with a penknife to

indicate light grasses. This brought the foreground closer in. It only remained to put in a post or two.

The painting had taken about two hours. It could have been quicker but time was wasted waiting for washes to dry. The colours used were:

1 *Cadmium Yellow*, 2 *Raw Sienna*, 3 *Raw Umber*, 4 *Burnt Sienna*, 5 *Burnt Umber*, 6 *Light Red*, 7 *Rose Madder*, 8 *Cobalt Blue*, 9 *Cerulean Blue*, 10 *French Ultramarine*, 11 *Winsor Blue*, 12 *Payne's Gray*.

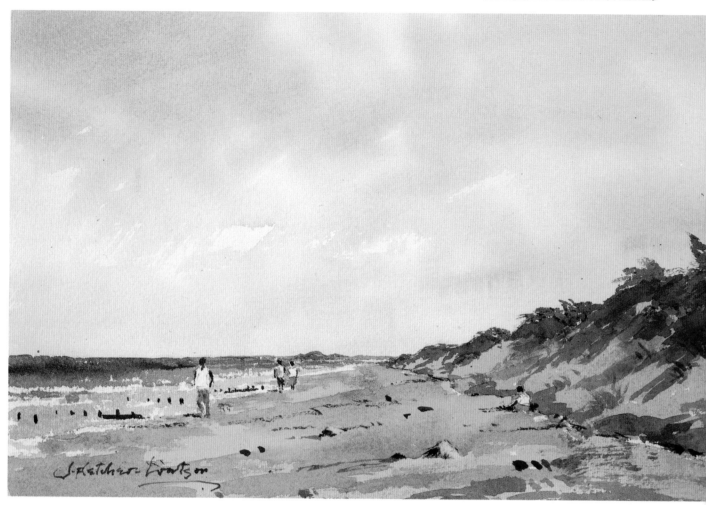

57 *Brancaster Beach, Norfolk.* 235 mm × 355 mm (9¼ in × 14 in)

At Brancaster, just next to Titchwell, there is a lovely sandy beach with a high sandbank partly covered with great tufts of marram grass, shown in **Figure 57** *Brancaster Beach*. It is a good example of making something out of almost nothing. As a matter of fact, I almost did not make anything — there was a strong wind and it blew the very dry sand all over my paper and paintbox, clogging the paints and my brush, which made painting extremely difficult!

58 *Stiffkey Saltmarshes, Norfolk.* 235 mm × 355 mm (9¼ in × 14 in)

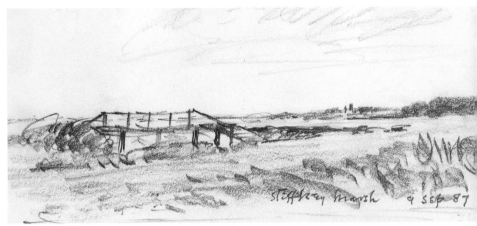

59 *Stiffkey Saltmarshes, Norfolk*

Further to the east there is a typical Norfolk scene, shown in **Figure 58** *Stiffkey Saltmarshes*, with Blakeney church and its two towers in the distance. With a big sky it makes a fascinating subject. I drew a quick pencil sketch first, seen in **Figure 59**, to check the composition, and then got on with the painting. I enjoyed every minute of it.

Figure 60 *Burnham Overy Mill* is a fine example of one of the massive tall cornmills, built probably about 1830. This one is well-preserved and very paintable, standing on the edge of a harvested stubble field. On a bright sunny day it makes a tempting subject for a painter.

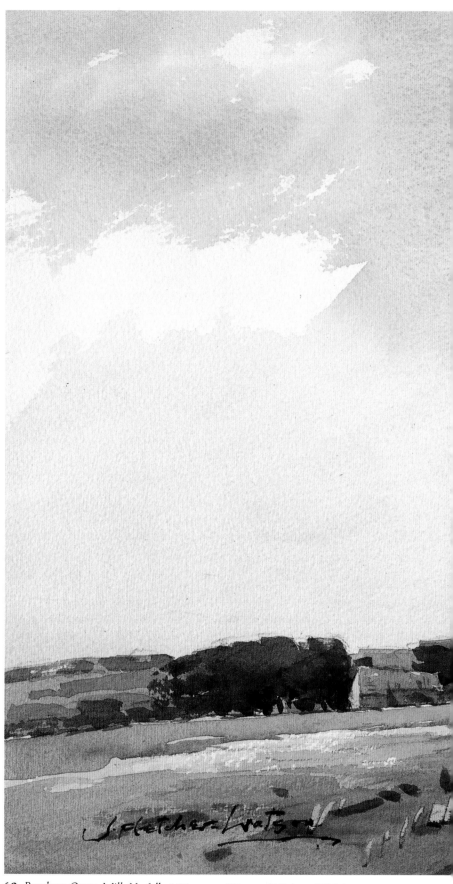

60 *Burnham Overy Mill, Norfolk.* 317 mm × 476 mm (12½ in × 18¾ in)

St Benets Abbey 6 Sep 87

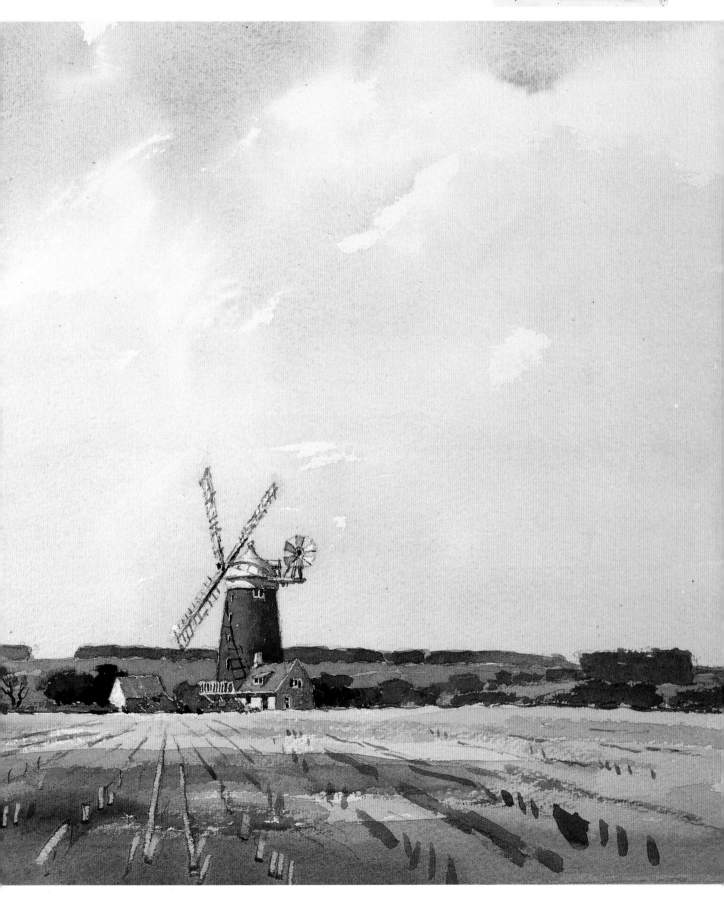

6 SEP 87 Ludham.
 Norfolk.

61 *Near Ludham, Norfolk*

For my last picture of Norfolk, I return to the Broads district. **Figure 61** *Near Ludham* is just a pencil sketch of a farm gate and a few autumn trees – another tempting subject, that could be a little masterpiece. It isn't *what* you paint but *how* you paint it that matters. Remember this when you are choosing a subject!

6

TUSCANY

Powerful sunlight, rapid painting, deep shadows, architecture, people

I recently took a party of painters to Tuscany and we were based at San Gimignano. It was a ten-day trip and it was enormously enjoyable.

Figure 62 *Piazza Cisterna, San Gimignano* (see overleaf) was the demonstration painting I made on the first day and a very lovely subject it was, right outside the front door of our hotel. I took $1\frac{3}{4}$ hours for this painting; I found it was necessary to paint fairly fast as in a hot climate watercolour dries very quickly. It was late afternoon and the shadows were extremely good. In an old Italian town with big squares and narrow streets, you have to plan the time of day very carefully to be sure you get the shadows more or less where you want them at the time of painting. At the same time, you do not want to be out in the hot sun in the middle of the day as it is too fatiguing. Unfortunately this painting trip had to be booked for late August, one of the hottest times of year, so we had to be especially careful! I found that vertical pictures suited the San Gimignano scene best (see also **Figure 66** on page 62 and **Figures 69** and **70** on pages 66 and 67).

I chose Whatman 200 lb Rough paper as I find this is good to draw on and good for applying quick watercolour washes. It is not absorbent like some papers, so enables you to

cope with the hot climate better. I used a 2B pencil for the drawing work. Before starting to paint, I thought carefully about the picture, particularly tone values and where my darkest darks and lightest lights were going to be. The darkest item was the arch to the right; the lightest items were the buildings on the right facing the sun, the stone floor of the Piazza and also the left-hand edges of the buildings facing us.

People were walking about everywhere and I had to decide where I wanted my figure groups. I drew in the figures at this stage as I would have to leave them unpainted when I was applying the building washes.

I got straight on with the sky, using fairly strong *Cobalt Blue* at the top and fading it to a lighter tone as I came down with the wash. I was *extremely* careful to paint round the outline of all the buildings. This wash dried beautifully quickly in the Italian sun.

Next for the buildings facing me, which were in shadow. The stone walls of these buildings varied a good deal from grey-yellow to brown-yellow. I used three colours (*Raw Umber, Burnt Umber* and *French Ultramarine*), varying the mixes on the different buildings as necessary. I used a no. 7 sable brush, starting on the fainter buildings to the left and working across to the

right, taking care to leave the white left-hand edges of houses and towers that were catching the strong sunlight. I also left white the sunny edges of windows and doors and the edges of the rectangular stone arch over the well-head. I painted all this fairly swiftly so that the details did not look too geometrical or careful. I kept it all rather loose in style, otherwise such a subject could start to look too rigid. Any figures which overlapped the buildings were left white.

Next I painted the well, its steps and the arch over it a rather darker tone than the houses behind. The white edges on top of the steps, etc., were carefully left unpainted. Various red roofs were now painted, using a small brush and *Burnt Sienna* and *Raw Sienna*. This included the *edge* of the overhanging eaves of the buildings in sun on the right. With a no. 5 brush I painted dark windows in on all the houses and towers, including the houses on the right. I varied the strength of tone; the colour was *Burnt Umber* with a little *French Ultramarine*.

The very dark pointed archway on the right was now painted with virtually the same colour as the windows but darker. I took care to paint round the sun umbrella of the café on the right.

Next I painted the deep wall shadow from the overhanging

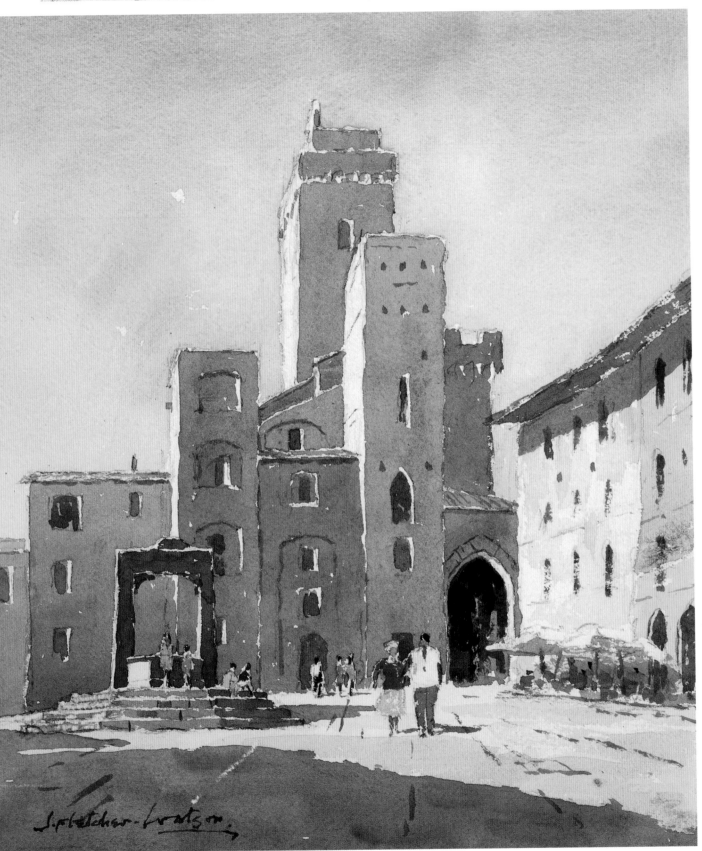

eaves of the buildings on the right. The colour was a mixture of *French Ultramarine, Light Red* and *Raw Umber*, giving a warm yellowish-grey tone. The projecting eaves themselves were a slightly darker tone.

We are about three-quarters of the way through now and only finishing touches remain. The café on the right required figures, tables and chairs. These were indicated with a small brush and a dark grey colour (*Cobalt Blue* and *Light Red*), with an occasional touch for a bright-coloured garment – *Cadmium Lemon, Rose Madder* or *Burnt Sienna*. The umbrellas themselves cast grey shadows, depicted in *Cobalt Blue* and *Light Red*.

The right-hand buildings received some delicate washes over their walls: some very faint *Rose Madder* on the far one and a light wash of *Raw Sienna* and *Payne's Gray* on the near one.

The arms, heads and legs of the man and woman in the foreground were painted with a small brush, using *Burnt Sienna* and *Cobalt Blue*, and *Payne's Gray* for his trousers. His shirt was left the white of the paper; her skirt was *Cadmium Lemon* and her top half neat *Indian Red*. The other,

more distant figures were touched in with blues, reds and yellows, leaving a touch of white here and there.

Only the ground paving now required painting. First I applied a light wash all over with a very light mixture of *Raw Sienna* and *Payne's Gray*, but leaving the far side white and untouched. When this was dry, a dark foreground shadow was applied coming from the buildings to the left, out of the picture. The colour was a subtle mixture of *French Ultramarine, Indian Red* and *Raw Sienna*. The same colour was used for the shadows from the well and the figures.

Finally, with a small brush I drew in a few perspective lines indicating paving or cartwheel tracks on the ground, in a *Burnt Umber* and *French Ultramarine* mixture. I scratched a white line in the shadow with my penknife. The picture was now complete. The colours used were:

1 *Cadmium Lemon*, 2 *Raw Sienna*, 3 *Raw Umber*, 4 *Burnt Sienna*, 5 *Burnt Umber*, 6 *Light Red*, 7 *Indian Red*, 8 *Rose Madder*, 9 *Cobalt Blue*, 10 *French Ultramarine*, 11 *Payne's Gray*.

62 *Piazza Cisterna, San Gimignano.* 317 mm × 280 mm (12½ in × 11 in)

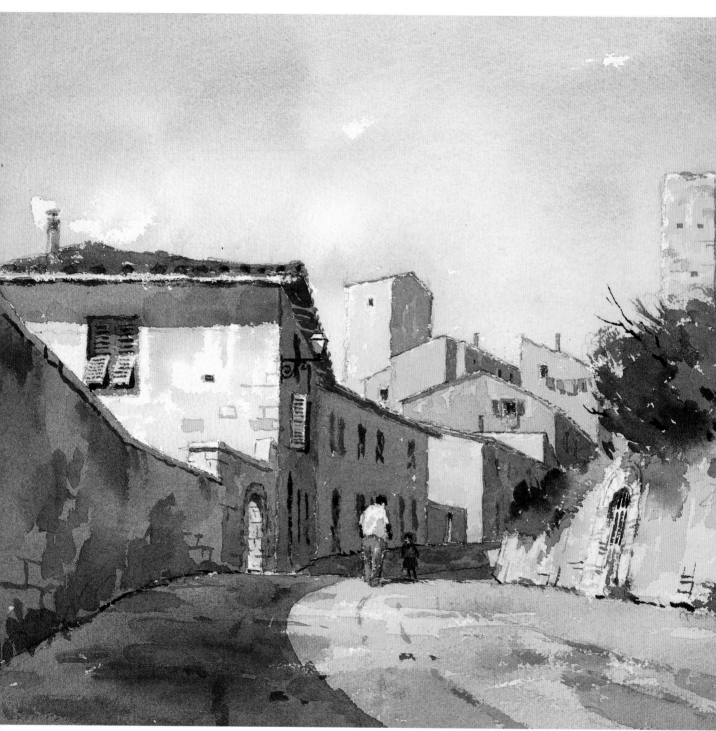

63 *On the Edge of the Town, San Gimignano.* 317 mm × 476 mm (12½ in × 18¾ in)

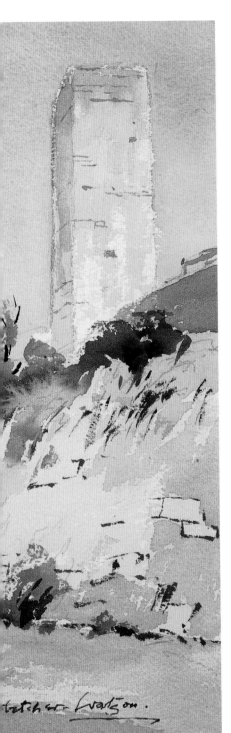

64 *On the Edge of the Town, San Gimignano*

The town of San Gimignano is very ancient and is built on top of a high hill; it has many tall towers and is fortified by a high surrounding wall with several strong entrance gates. When exploring, I came across the view in **Figure 63** *On the Edge of the Town*. It was unfrequented by the hordes of tourists and was ideal for my sketching party to sit and paint. I first made a quick pencil sketch, shown in **Figure 64**; I felt that everyone could manage this, although there was more perspective in it than the last. I sat rather further back for the actual painting and this widened out the view nicely. The foliage helped to break the monotony of the buildings, and the battered retaining wall on the right was an interesting feature. The towers made good vertical foils to the horizontal lines of road and houses.

59

Figure 65 *Village, Tuscany*, was only a few miles from San Gimignano and was a wonderful find. Only a small group of the party joined me for this painting, my daughter Josephine being one of them, and it was possible for us all to huddle into a small piece of shade. It was an extremely hot day and even with the shade we all nearly died! It was necessary to use a little more water than usual for the colour mixes because of the quick drying. I was again using Whatman paper.

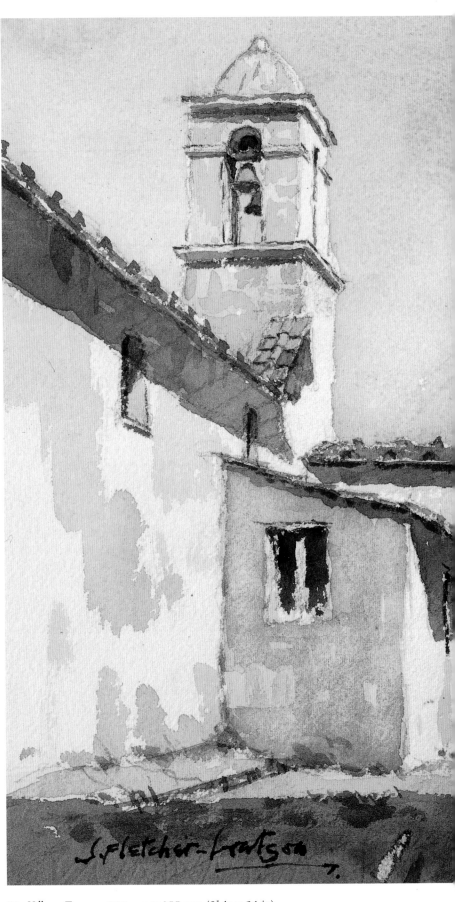

65 *Village, Tuscany.* 235 mm × 355 mm (9¼ in × 14 in)

60

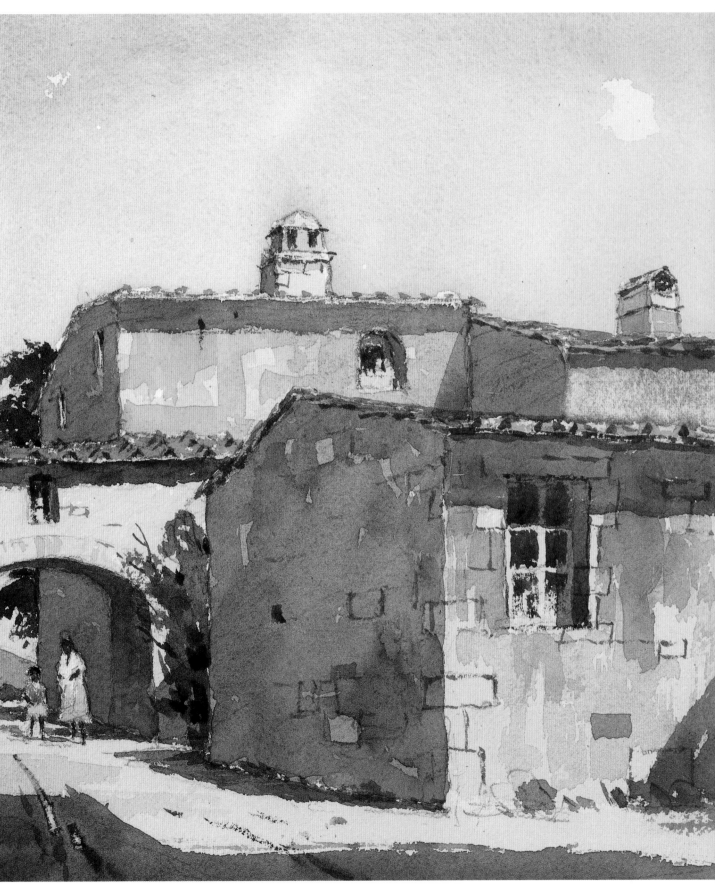

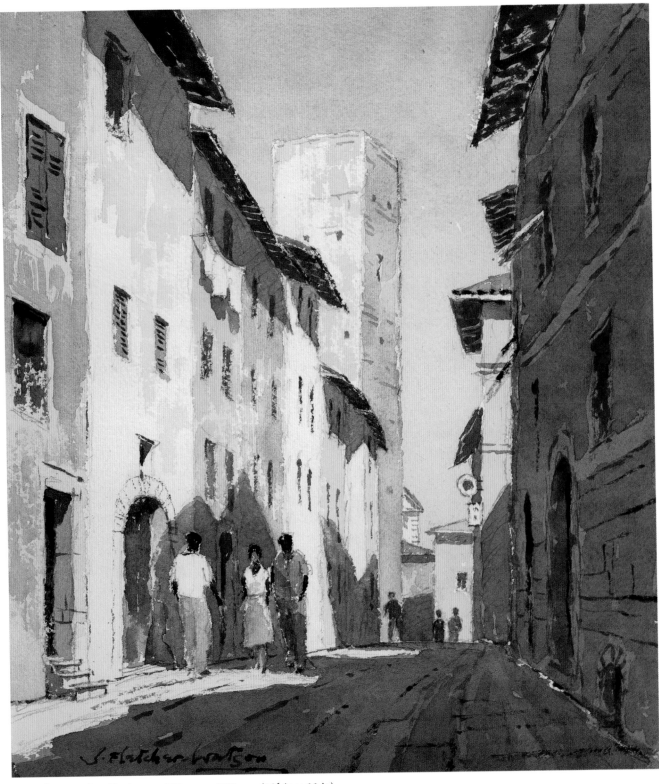

66 *Side Street, San Gimignano.* 317 mm × 280 mm (12½ in × 11 in)

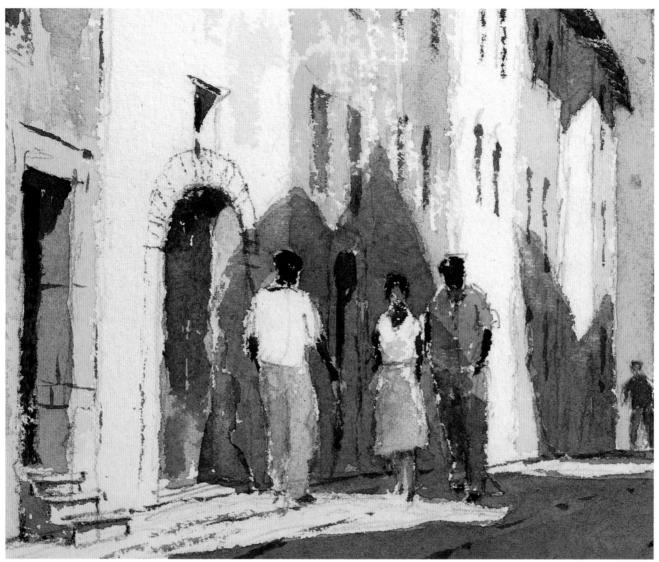

67 Detail of Figure 66

Another attractive scene is shown in **Figure 66** *Side Street, San Gimignano*. This was a very narrow street, only about 4·5 m (14 ft) wide, and in the midday sun the shadows were fascinating. I painted fast as the shadows were changing minute by minute. I think it is almost my favourite picture of the visit.

The various figures play an important part, the distant ones helping with the perspective. The closer group of three figures is the key to the composition: the man's bright shirt in neat *Light Red*, together with the other two white shirts, give the necessary sparkle and focal point.

Figure 67 shows an enlarged detail of the figure group. Note the tone values of the wall shadows, and the strong colour of the round-headed doorway and the small window above it.

We made a day trip for the picture shown in **Figure 68** *Siena.* I am sure many readers know this beautiful town with its enormous central square and cathedral. It is a very lovely composition seen from a distance.

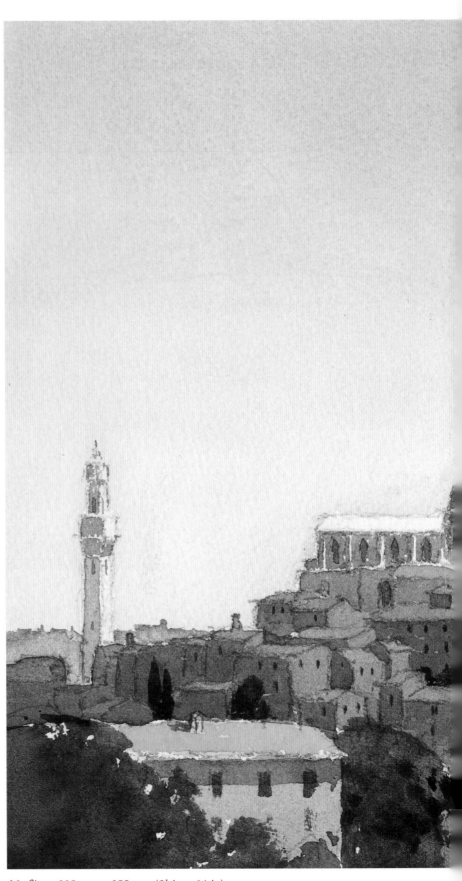

68 *Siena.* 235 mm × 355 mm (9¼ in × 14 in)

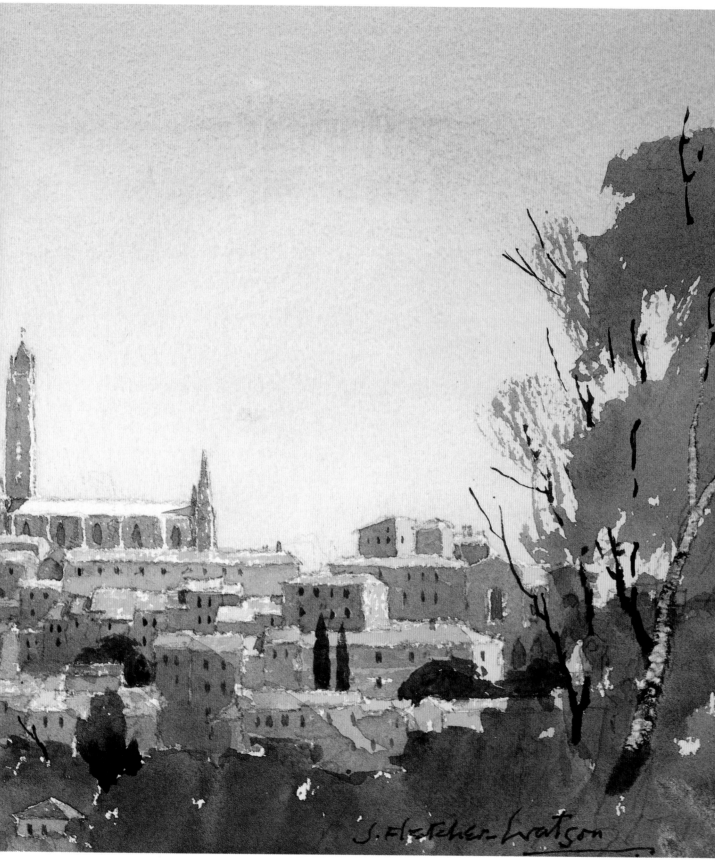

On the morning we left San Gimignano I just had time for a quick pencil sketch. It was of a busy street leading downhill to one of the exit gates, shown in **Figure 69** *Via S. Matteo*. I drew this view with a 5B pencil in about 15 minutes. At home the following month, I made a watercolour painting of it on Winsor and Newton artists' watercolour paper, seen in **Figure 70**. I had not had time to note down any colours on the pencil sketch but by the end of the trip I knew them pretty well by heart!

69 *Via S. Matteo, San Gimignano*

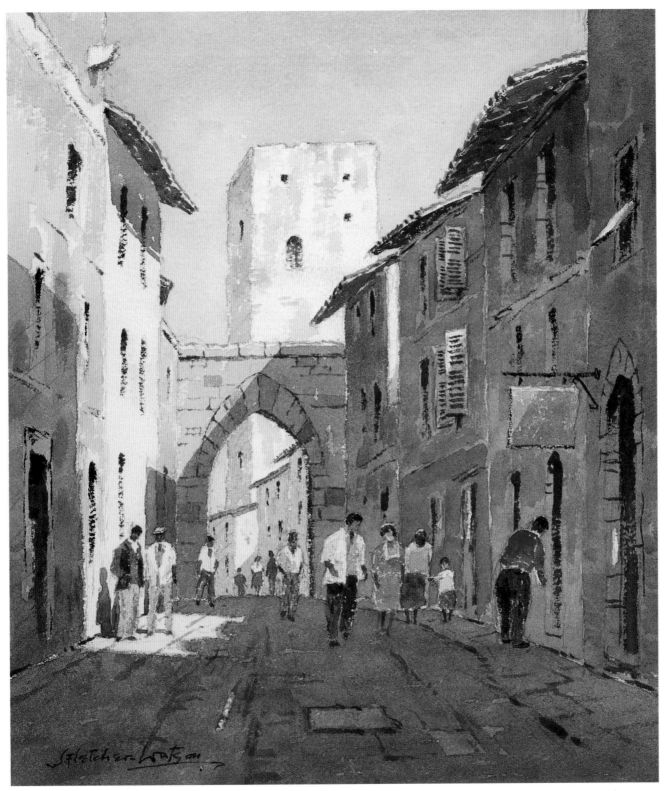

70 *Via S. Matteo, San Gimignano.* 362 mm × 311 mm (14¼ in × 12¼ in)

7

WALES

Cloudy skies, rivers, bridges, cottages, mountains

WALES is a romantic country full of mountains and rivers, and the Welsh are a romantic and musical people with wonderful voices and famous choirs. The countryside is remarkably unspoilt in this modern age, and untouched farms and cottages abound to delight the painter's eye.

I stayed in the Black Mountains in South Wales not long ago with a small party of painters, and while I was exploring for a suitable subject for a demonstration I discovered the view shown in **Figure 71** *Bridge on the River Usk, near*

Abergavenny. I made this pencil sketch in a larger sketchbook (20·5 cm × 29 cm; 8¼ in × 11½ in), with some colour notes in case I had to do the demonstration painting indoors if the weather turned nasty on us. It can be very wet in Wales! But all was well, the next day was perfect with cloud and sun and we all painted out of doors on the spot.

Figure 72 shows the finished picture. Composition is of first importance with a subject like this. Note the high mass of tree to the left counterbalanced by a lower tree group on the right, with the bridge and distant view through the centre arch holding the main interest. The rocky foreground and slight bend in the river were useful.

71 *Bridge on the River Usk, near Abergavenny*

72 *Bridge on the River Usk, near Abergavenny.* 317 mm × 476 mm (12½ in × 18¾ in)

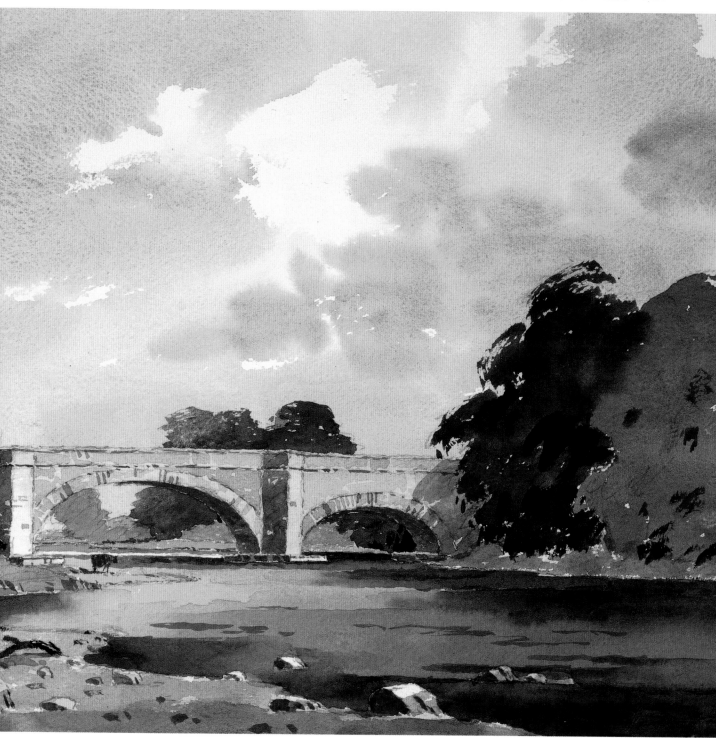

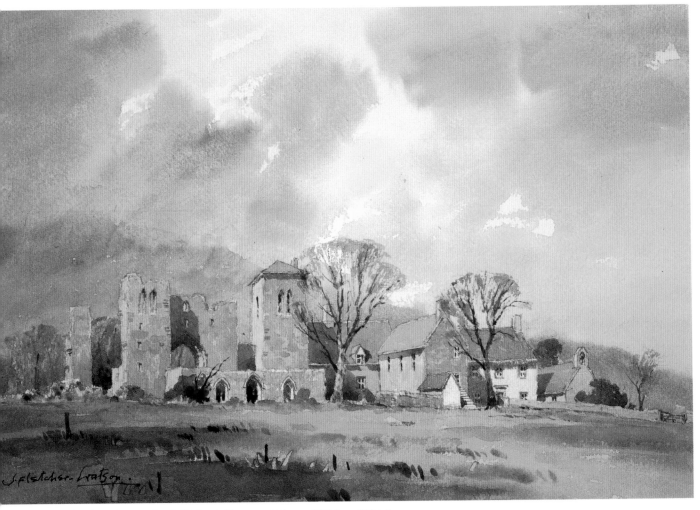

73 *Llanthony Priory, South Wales.* 317 mm × 476 mm (12½ in × 18¾ in)

Travelling a few miles north into the heart of the Black Mountains along a small road that eventually turns into a rough track, you come to a gorgeous old monastic ruin, shown in **Figure 73** *Llanthony Priory*. This was romantic Wales at its best. Unfortunately the weather was threatening and halfway through the painting I had to give up and take shelter in the car. I finished the picture indoors later from memory.

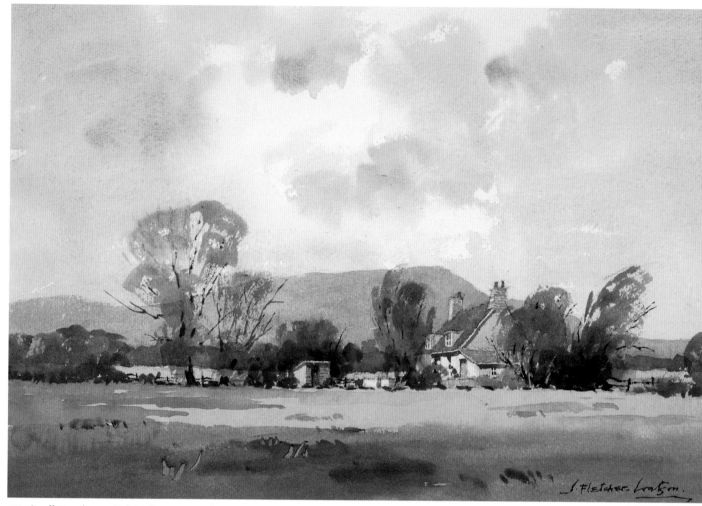

74 *Small Farmhouse, Usk Valley.* 317 mm × 476 mm (12¼ in × 18¾ in)

Still in South Wales, I discovered a very lovely little subject, seen in **Figure 74** *Small Farmhouse, Usk Valley.* The Black Mountain range shows in the background. This would be an ideal subject for a not very experienced artist to paint. The middle distance consists of trees and the small house; the background is a simple grey wash for the mountains and the foreground a flat field of rough grass with a few cloud shadows and grass tufts to give texture. The cloudy sky consists of blue and grey washes. Always aim at simplifying nature by looking at your subject with half-closed eyes.

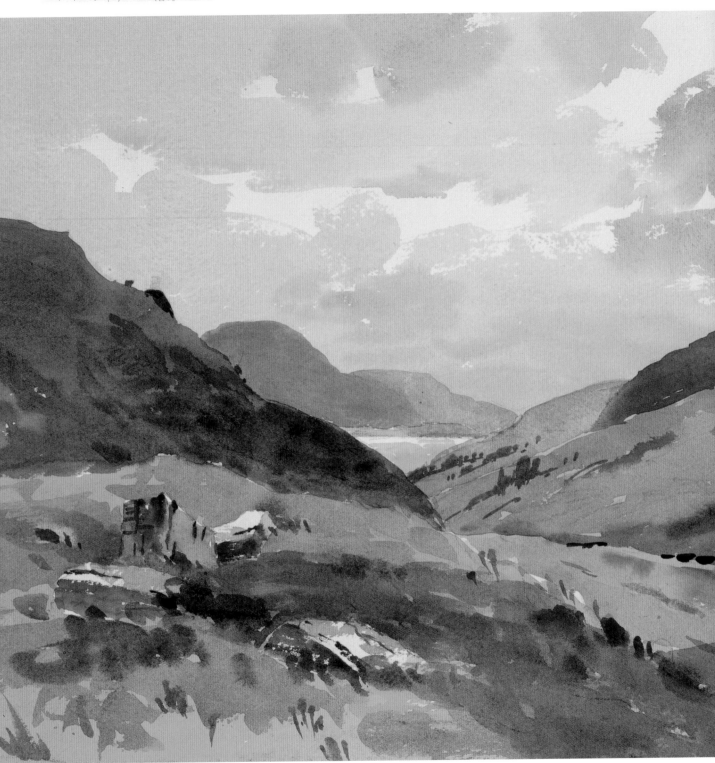

75 *Tal-y-Llyn from Mountain Pass.* 317 mm × 476 mm (12½ in × 18¾ in)

76 *Tal-y-Llyn from Mountain Pass*

Three years earlier I was in North Wales near Machynlleth and the Cader Idris Mountains. There is a wonderful lake called Tal-y-Llyn, which can be seen in the distance of the next picture, **Figure 75** *Tal-y-Llyn from Mountain Pass*. For some reason, I was pressed for time and was unable to paint this picture on the spot, so I made a pencil sketch in a small sketchbook, shown in **Figure 76**. I noted various colours and that there was a cloudy sunny sky, hence the fairly evident cloud shadows over certain areas of mountain in the painting. This was an excellent subject and a road leading into a picture always adds to the depth.

77 *Cottage near Abergynolwyn.* 235 mm × 355 mm (9¼ in × 14 in)

Still in North Wales, exploring up a little cart track one day I came across the delightful subject seen in **Figure 77** *Cottage near Abergynolwyn*. I chose Whatman paper for this sketch, and as I sat looking at the subject I pondered a little on how I wanted to paint it. The peaceful mountain setting and the pale grey sky with a touch of blue in it suggested a really simple watercolour treatment. I wanted to get the feel of the place; just an impression without detail.

Having drawn in the cottage lightly with a 2B pencil and indicated the mountain outlines, I started by laying in the sky with *French Ultramarine* and *Burnt Umber*, keeping the wash damp to give soft edges to the clouds. When this was dry I could paint in the left-hand high hill with *Raw Sienna* and *French Ultramarine*, adding some clear water at the top to suggest the overhanging low cloud.

I carried this dull green wash all over the picture except for the cottage, which I left white; I also left the area on the right where the mountain showed in the distance. I painted in this mountain, using *French Ultramarine* and *Light Red*.

After these washes had dried, I could paint in the various tree groups and the bushes in the

right-hand foreground with a mixture of *Raw Sienna*, *Winsor Blue* and *Burnt Umber*. These three colours will give you an infinite variety of tone. The tree behind the cottage chimney received an extra dark application, mostly strong *Burnt Umber* and *Winsor Blue*. The little bush and sapling in front of the cottage received the same dark mixture, using a small brush, of course. I had been using a no. 10 brush for most of the other work. I carefully painted round the washing on the line with a small brush.

Next it was time to fill in the cottage details, using *Winsor Blue* and *Light Red* for the roofs and a strong mixture of *Burnt Umber* and *French Ultramarine* for the windows. The doors were *Burnt Umber* on its own.

It only remained for the shadows under the roof eaves to be put in with *French Ultramarine* and *Light Red*, and a few lines of a grey-green colour on the cart track, suggesting tufts of grass in the foreground. Finally I added bright touches of pink and blue on the washing and figure in the garden. This little sketch did not take more than one-and-a-half hours and only five colours were used: 1 *Raw Sienna*, 2 *Burnt Umber*, 3 *Light Red*, 4 *French Ultramarine*, 5 *Winsor Blue*.

8

AMERICA

*Arizona Desert, mountains, clapboard buildings,
painting in 100° F, masking fluid*

PAINTING in Arizona in April proved to be hot work with the temperature around 100°F. I found it necessary to have more water in some of the mixes to overcome the quick drying of the paint caused by the hot sun.

Figure 78 *Giant Cacti in Arizona Desert* was a case in point. I was using Whatman paper and the sky wash of *Cobalt Blue* fading to *Raw Sienna* was well diluted and washed down slowly to the horizon. The rough grasses and bush areas also had to be kept pretty wet, and I found the use of masking fluid for the little birch tree on the right and the white shirt of the man a considerable help.

I expect you all know this technique. Using a small brush, you paint the masking liquid on the objects you want to be white before you start any of the bush foliage, etc., and then when it is quite dry you can sweep on the wet washes right over the tree trunk and figures. When the washes are completely dry, you gently rub the masking fluid with a clean finger or an eraser, and it peels off, leaving the white features ready for you to touch up with a small brush as required.

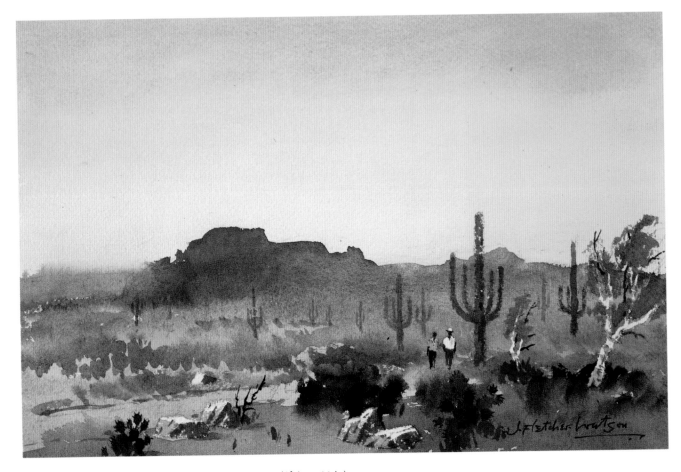

78 *Giant Cacti in Arizona Desert.* 235 mm × 355 mm (9¼ in × 14 in)

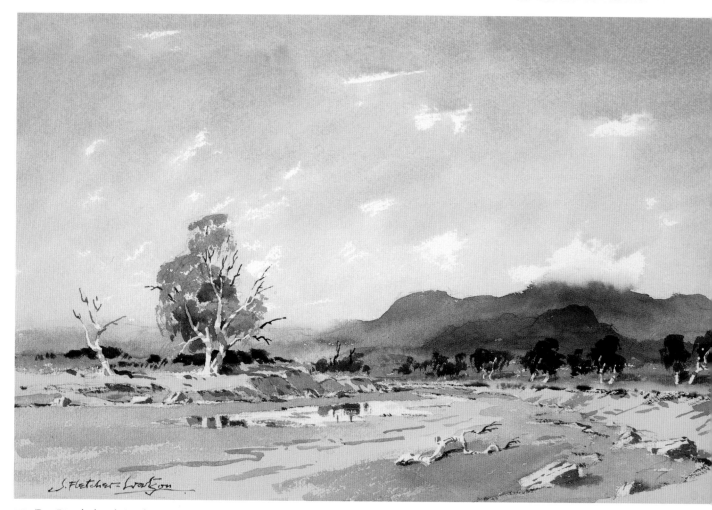

79 *Dry Riverbed and Catalina Mountains, Tucson.* 317 mm × 476 mm (12½ in × 18¾ in)

One of the best subjects I found in America was the view shown in **Figure 79** *Dry Riverbed and Catalina Mountains, Tucson.* I was glad to find my fourteen colours quite suitable for the lovely tones of Arizona.

I used watered-down *Cerulean Blue* for the sky and *Indian Red* with *French Ultramarine* for the rather purple mountains. Quite a lot of *Burnt Sienna* and *Burnt Umber* was required for the areas beyond the riverbanks, and the riverbed itself was mostly *Raw Sienna* toned down with *Payne's Gray*. The most exciting part was the two partly dead old trees. I again used masking fluid for the trunks, applied before the painting began, and also for the little trees on the right. I do not know what type of trees these were, but I should think some sort of birch or eucalyptus. The old trees on the left bank were beautiful shapes; I used *Raw Sienna, Burnt Sienna* and *Burnt Umber* for the foliage.

80 *Milford, Connecticut.* 235 mm × 355 mm (9¼ in × 14 in)

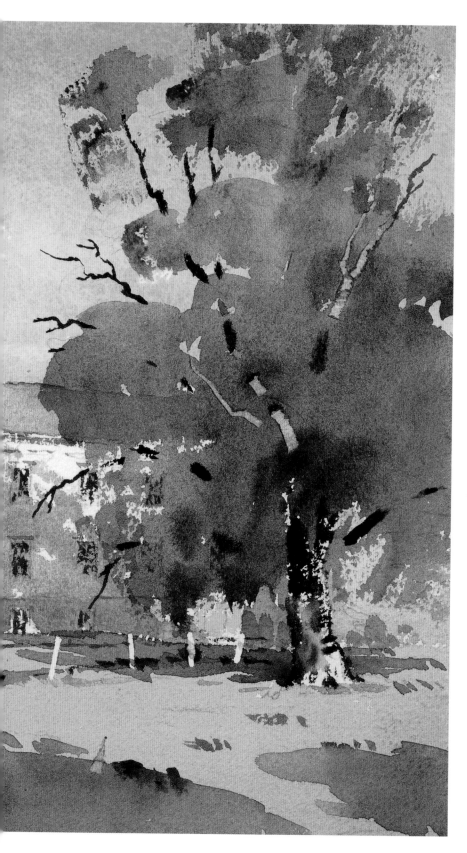

Moving now to Massachusetts and New England on a different occasion, we stayed part of the time with my daughter Vanessa and discovered the glories and magic of this unique part of the United States.

Figure 80 *Milford, Connecticut* shows a very beautiful and very typical New England eighteenth-century church. It was entirely built of timber, with white-painted clapboard covering the outside walls and a tower and spire structure. The blue clock is a nice feature and the surrounding trees and parkland are a delight. It was again hot weather so I used masking fluid for the tree trunk on the right, but nowhere else in the picture.

American colonial architecture has a great fascination for me, as the architects, carpenters and master-builders who went to America in the eighteenth century produced a classical style that was a very attractive refinement of the style Christopher Wren created in England in the 1670s. James Gibbs, Wren's pupil, produced pattern books and fully illustrated builders' handbooks which the American builders undoubtedly used as a guide, but they nevertheless produced their own unique American style, suited to a hot climate.

For the shadows on the white church building I used *Cobalt Blue* and *Light Red*. For the trees it was mostly *Raw Sienna* with a little *Winsor Blue* and *Burnt Sienna*.

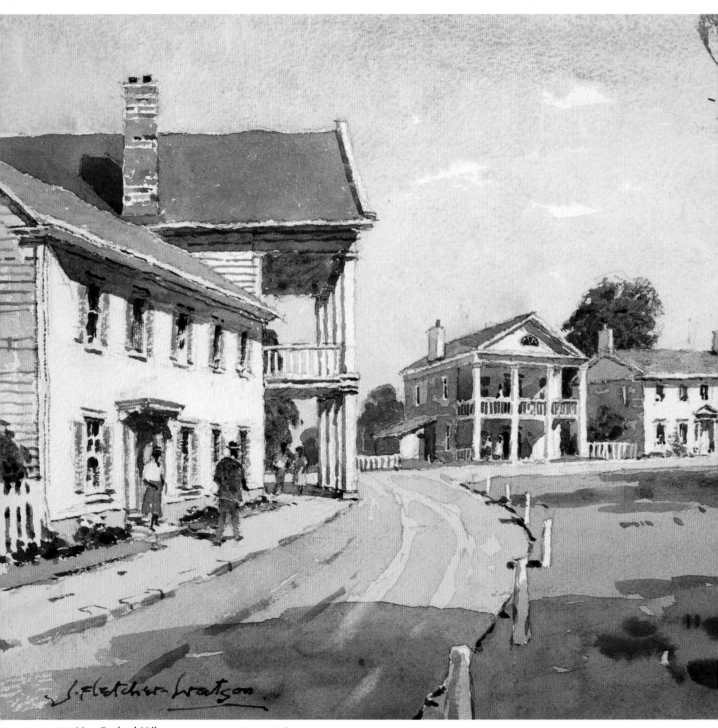

81 *New England Village.* 235 mm × 355 mm (9¼ in × 14 in)

The charming village we came across in **Figure 81** *New England Village* had houses round a large village green with old trees on it. A very pleasing feature was the first-floor outside balcony with railings and lofty columns supporting the overhanging roof. Everything was painted white as usual – we didn't see a single shoddy unpainted building during our stay in New England. (The upkeep must be expensive!) I used the technique of leaving the white of the paper for the white houses and columns.

AMERICA

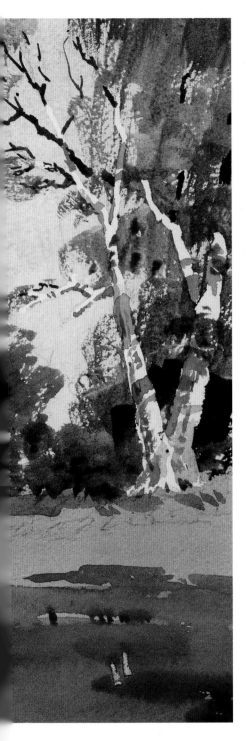

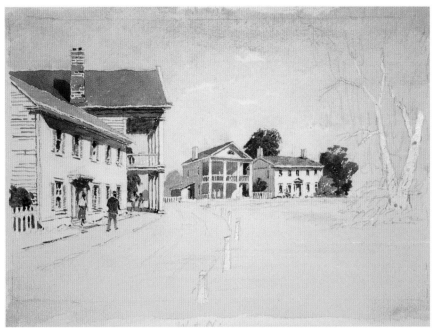

82 Stage 1 of painting Figure 81

Figure 82 shows *Stage 1* of *New England Village*. On the extreme right the white tree trunk is another instance where I have again used masking fluid. I also used masking fluid on the white posts on the grass.

The next stage of the picture was to paint the foliage of the large tree, adding some darker branches to the light ones, and the green grass and road, with suitable shadows. Finally I rubbed off the masking fluid and painted grey shadows on the tree trunk.

Figure 83 *Architectural Features* (see overleaf) shows some sketches I made of typical architectural details that we noticed on our travels round New England:

A shows a typical sash window with wooden shutters, very often painted black or blue-grey.
B is the entrance gates to a private house, all made of wood and painted white – very elegant and impressive.
C shows a lovely door with windows each side and a large fanlight above: what we would call Regency style in England.
D is a delightful feature and very typical – a verandah below and balcony above, all in timber.
E is a church entrance with double doors, this time with quite elaborate mouldings and carvings very much in the Wren tradition. This sketch is pencil only with no colour.

All these sketches will be useful to me in the future when I want to paint a New England subject from one of the pencil drawings in my sketchbook.

Connecticut U.S.A.

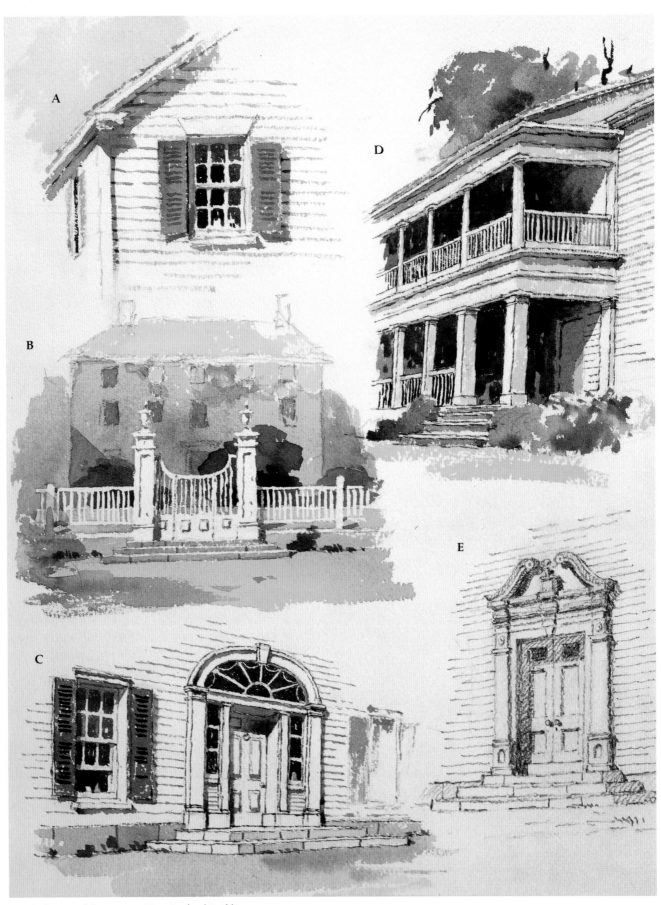

83 *Architectural Features on New England Buildings*

9

WILTSHIRE

Salisbury Cathedral in snow, thatch-roofed stone cottages, autumn trees

THE view shown in **Figure 84** *Salisbury Cathedral in the Snow* is remarkable, as one is quite close to the city and yet there is not a house in sight. The painting is from due west and there are quite a number of views from the south-west, also across fields. I sincerely hope these beautiful scenes will never be spoilt by development.

I used my old friend Whatman paper for this subject. The composition was an important consideration and I felt that the spire just right of centre was the perfect position, with the weighty block of woods to the right and the more distant longer group of trees to the left.

I had, of course, to make a fairly careful drawing of the cathedral first, getting the proportion of spire and tower in the correct relationship with the transept roofs, etc. The spire is the tallest in England, and it certainly takes some careful drawing to get it dead vertical!

The cloudy sky was put in with a wet wash of *French Ultramarine* at the top, fading to *Cobalt Blue* lower down. I carefully left the spire and roofs perfectly white and untouched by the blue.

84 *Salisbury Cathedral in the Snow.* 317 mm × 476 mm (12½ in × 18¾ in)

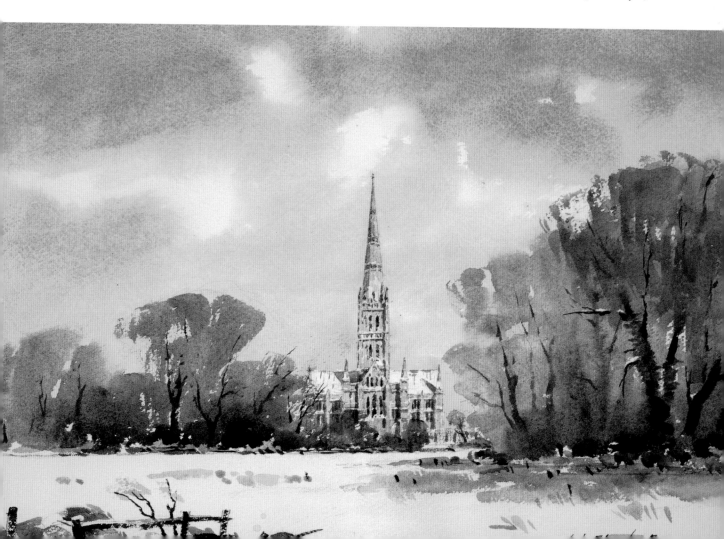

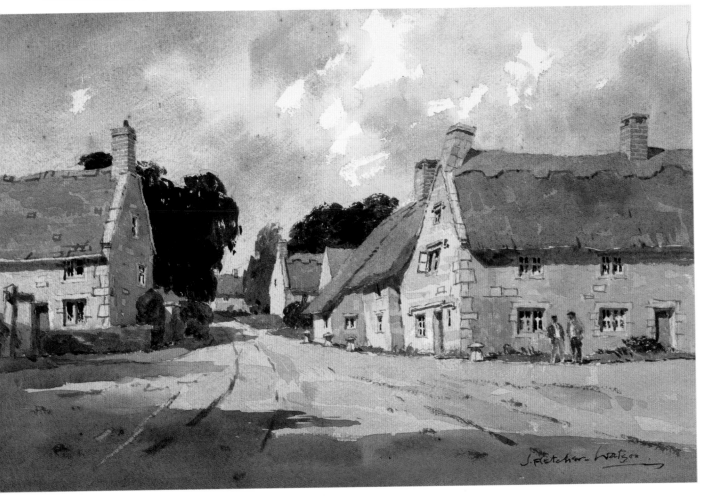

85 *Chilmark, Wiltshire.* 317 mm × 476 mm (12½ in × 18¾ in)

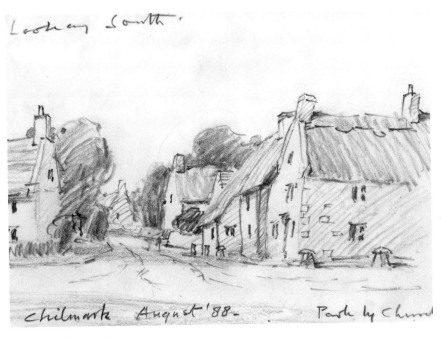

86 *Chilmark, Wiltshire*

When all was absolutely dry, I painted in the cathedral with a small brush and *Raw Umber* with a little *Payne's Gray*. The roofs and various places where the snow was lodging were left white. I next put in the windows and bits of carving with *Burnt Umber* and a little *Payne's Gray*, followed by the shadows, using *Cobalt Blue* and *Light Red*.

Now for painting the trees. The wood on the right was painted in *Burnt Umber* with *French Ultramarine* in differing mixtures, using the same two colours rather more strongly for the trunks and branches. The ivy-clad trunk had green added, a mixture of *Winsor Blue* and *Raw Sienna*. The left-hand group of trees received the same wash with some *Burnt Sienna* in places.

87 *Autumn Trees, Hanging Langford, Wiltshire.* 235 mm × 355 mm (9¼ in × 14 in)

The foreground bushes and posts were various mixtures of *Raw Umber, Burnt Umber* and *Cobalt Blue.* Finally I painted snow shadows extending from the wood and on undulating ground, using a mixture of *French Ultramarine* and *Light Red.*

Not far from Salisbury in the Wylye Valley is a delightful village of stone cottages, many of which still have thatched roofs. The view in **Figure 85** *Chilmark, Wiltshire* is at the village crossroads, the road behind me going up to the church. It is nice to think that there are still some English villages where there is practically no traffic and you can sit in the road for two hours without any trouble!

I first made a quick pencil sketch, shown in **Figure 86**, just to test the composition. You may notice that the cottage on the right has a very leaning chimney. This is not bad drawing by me, it really was sloping like this!

This was painted in August when the trees are really dark green. This dark tone has the effect of showing up the light colour of the stone walling and the thatched roofs, and it helps to emphasize the strong sunlight. Some people are inclined to be timid with their greens for trees, but if you half-close your eyes you get the tone value of an object and can learn to be bold with your washes.

There are many pleasant rivers in Wiltshire and my next view is on the River Wylye, **Figure 87** *Autumn Trees, Hanging Langford* — what an attractive name that is. This slow-running river gives good reflections. They are the last items you paint in the picture; everything else has to be done first, leaving the river completely white until all the features are there ready to be reflected.

The right-hand tree consisted of *Raw Sienna* with a touch of *Burnt Sienna* and *Payne's Gray.* The tree to the left of it was *Raw Umber* and *Cobalt Blue.*

This was a beautifully simple subject and I recommend the less-experienced painter to have a go at something similar to this.

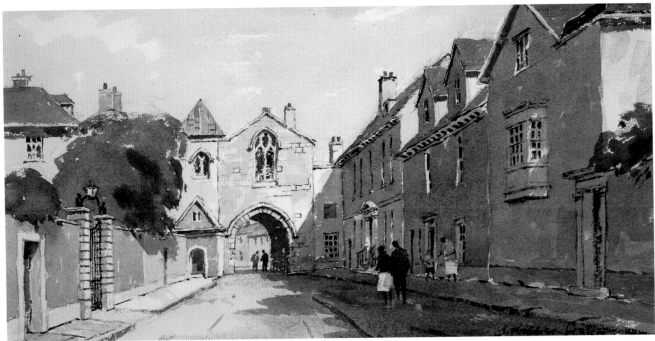

88 *Salisbury Cathedral Close.* 242 mm × 476 mm (9½ in × 18¾ in)

Let us now look at an architectural subject, **Figure 88** *Salisbury Cathedral Close.* This is a nice little corner showing one of the entrance gates. (All the gates are firmly closed at night, an old tradition.) I chose this view partly because the shadows were right; you always want to consider this aspect of things before painting a building subject. It was midday and the sun from the south was on the right, throwing a good shadow across the gatehouse and leaving the right-hand houses all in shadow, which gave a nice sunny aspect to the other buildings. I chose an elongated shape for my picture as I did not want too much sky.

You will notice that there is quite a lot of drawing with a small brush and a dark brown mixture (*Burnt Umber* and *Payne's Gray*). This is to pick out cornices, windows, doorways and the iron gates and gate piers on the left, and of course the Gothic arch and stonework of the gatehouse. All this was done about halfway through the painting, after the main washes but before the dark shadow on the right-hand buildings was floated in.

10

VENICE

*Dramatic compositions of beautiful buildings,
bridges, reflections, shadows on buildings in sunshine*

VENICE is such a varied city that you always seem to be able to find a new subject. On one of our many visits I wandered into the little courtyard shown in **Figure 89**. No tourists had ventured here and I did this quick pencil sketch with no interruptions. The sun and shadows were excellent and I liked the washing hanging out. I noted a few colours on the drawing. I made a painting from this sketch at home a few months later, shown in **Figure 90** *Corte del Fontego* (overleaf).

On a fine sunny day with clouds, I made a larger painting of one of the more well-known views, **Figure 91** *Grand Canal and S. Maria della Salute* (overleaf), from a jetty. I have already shown this view in a rough pencil sketch in **Figure 18** on page 16.

The drawing work did not take long. I sketched the distant church and other buildings quite quickly and lightly with a 2B pencil as I wanted to leave most of the work for the brush. The left-hand foreground buildings did not need much careful pencil work; I wanted to render them in a quick, loose way so they would not hold the attention too much.

After dampening the sky area, I laid on a grey wash, with a no. 10 brush, of well-diluted *French Ultramarine* and *Burnt Umber* – they were only light-toned clouds. I left white spaces

89 *Corte del Fontego, Venice*

for the few areas of *Cobalt Blue*, and lower down I ran in a little *Raw Sienna*. The very distant strip of land and low building was a grey smudge of *Cobalt Blue* and *Light Red*.

Next I painted the church with the dome and all the buildings on the far side. I used three colours for most of this work: *Cobalt Blue*, *Light Red* and *Raw Sienna*, which gave a general grey-yellow tone. The church and the adjoining distant group were virtually all grey. As I came along to the right, I worked in a stronger grey-yellow. Eventually I used *Burnt Umber* for the windows and roofs, etc., but not too strong a mixture. A few

moored boats were also included.

The buildings on the left could now be painted with a slightly larger brush, a no. 7. The light washes on the walls were a variety of *Raw Umber*, *Burnt Sienna* and *Burnt Umber*, all well diluted almost to the paper tone in places. I then dashed in, with quick brush strokes and a no. 7 or no. 5 brush, the windows, doors, balconies and eaves' shadows, using *Burnt Umber* and a touch of *Payne's Gray* in a fairly strong mixture.

The mooring posts had carefully been left white until now, when I painted their pink stripes. I also painted the gondolas sticking out at the

90 *Corte del Fontego, Venice.* 210 mm × 356 mm (8¼ in × 14 in)

corner, using a dark brown mixture.

Now I was only left with the water to do. This was a very slightly darker tone than the sky, and I laid this grey wash over the water area, adding a touch of *Cobalt Blue* as necessary. As this dried, I painted into the grey wash the strong reflections in the water on the left. I used *Burnt Umber* and *French Ultramarine*, making a warm brownish-blue. The same colour but in a lighter tone was used for the reflections on the far side of the canal.

I next added the various boats in the distance with *Burnt Umber* mixed with *Cobalt Blue*. I put in a few ripples on the water's surface with some thin brush strokes, using a blue-grey colour mix.

This picture took just under two hours and the colours were:

1 *Raw Sienna*, 2 *Raw Umber*,
3 *Burnt Sienna*, 4 *Burnt Umber*,
5 *Light Red*, 6 *Cobalt Blue*,
7 *French Ultramarine*, 8 *Payne's Gray*.

91 *Grand Canal and S. Maria della Salute, Venice.* 317 mm × 476 mm (12½ in × 18¾ in)

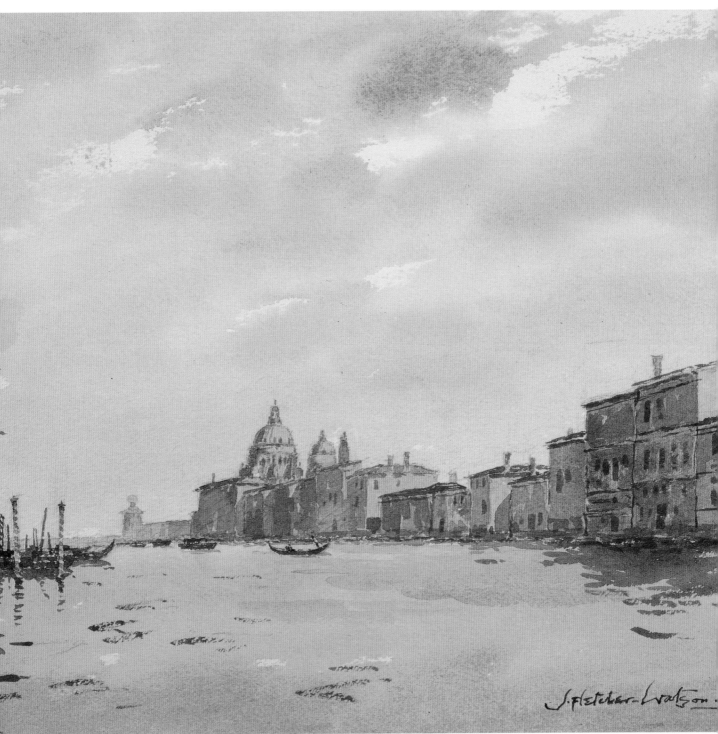

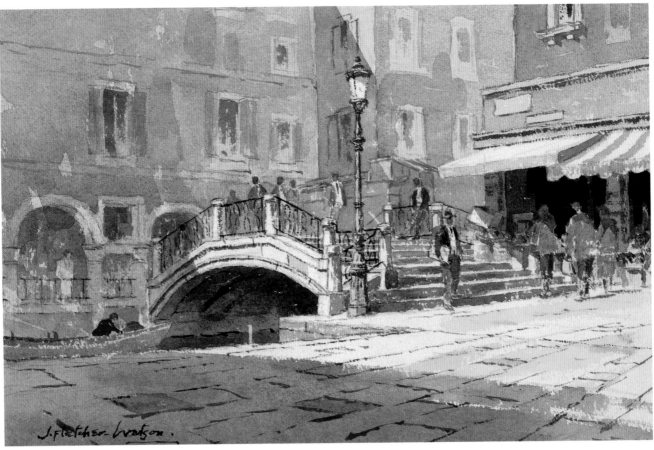

92 *S.S. Apostoli Campo, Venice.* 235 mm × 355 mm (9¼ in × 14 in)

93 *Rio Tera, Barba Frutariol, Venice*

A small subject is shown in **Figure 92** *S.S. Apostoli Campo.* I was concentrating here on the small bridge on the left, the vegetable stalls under the awnings to the right, and the constantly moving crowd going back and forth. The brilliant sunlight catching the bridge and foreground paving is what gave the scene its charm.

I filled many pages of my A5 sketchbooks in Venice with very quick, rough sketches to act as memos to tell me where to go for a subject to paint. **Figure 93** *Rio Tera, Barba Frutariol* is typical, just dashed off in a few minutes but enough to remind me of a paintable little scene. Some of the narrow back streets are well worth exploring, away from the smart tourist areas, but it is very easy to get completely lost in Venice!

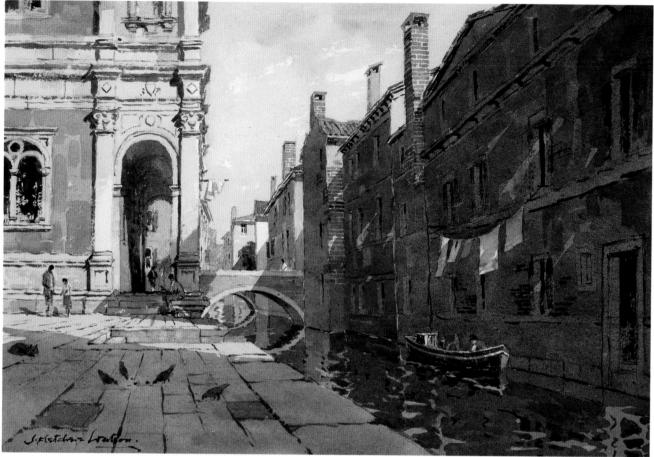

94 *S. Rocco and the Frescada Canal, Venice.* 317 mm × 476 mm (12½ in × 18¾ in)

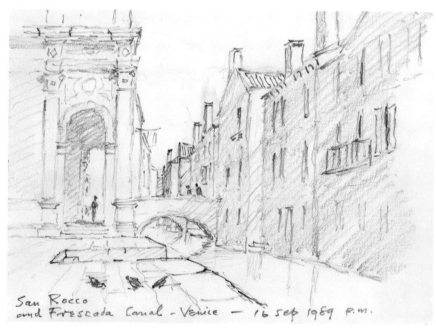

95 *S. Rocco and the Frescada Canal, Venice*

Figure 94 *S. Rocco and the Frescada Canal* was a great find; a mixture of a high-class building with some rather slummy ones made a fascinating subject. I first made a pencil sketch, shown in **Figure 95**, to see if it built up into a good composition. It was unusual but I felt it was going to work.

The intriguing part was the very tall, vertical, slender arch with the stone pilasters and Corinthian caps, and the small bridge giving a contrasting horizontal accent together with the canal itself. A further vertical counterpoise was supplied by the row of tall chimneys. Throughout there was a nice mixture of brickwork and stonework which gave interesting relief to the general colour scheme.

91

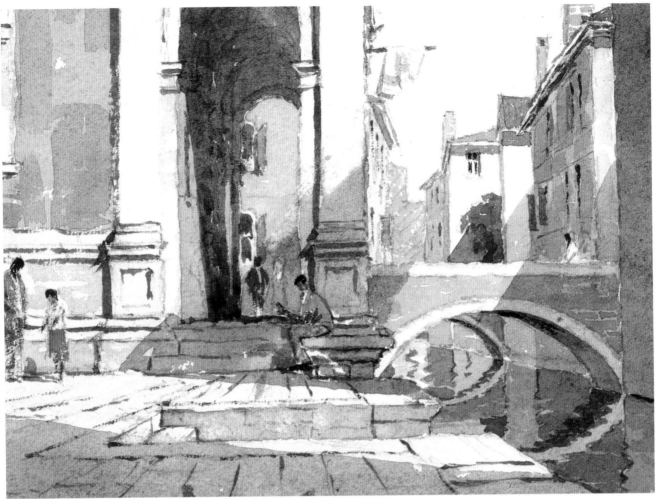

96 Detail of Figure 94

Figure 96 shows an enlarged detail of the focal point of the picture. The figure sitting on the steps and the distant figure through the arch give scale. You can see here how drawing with a small brush suggests architectural details.

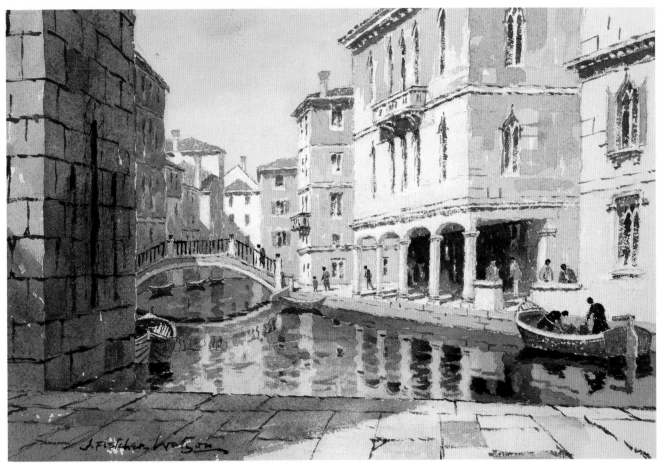

97 *Rio di S. Sofia, Venice.* 235 mm × 355 mm (9¼ in × 14 in)

I came across the subject shown in **Figure 97** *Rio di S. Sofia* quite by chance. I am sure this nice little covered way with a colonnade was a market on certain days, so conveniently was it placed where boats could pull alongside. The buildings jutted out in a wonderfully haphazard way, and there were good reflections and an interesting sky shape.

After a painting trip to Venice, I always find I have learned something new. To me it teaches more about composition than anywhere else. It makes you develop an eye for design, and the layout and grouping you are going to arrange on your clean piece of watercolour paper. In short, it is inspiring, and I hope any of my artist readers who have never been to Venice will try to go there as soon as possible.

11

AUSTRALIA

A hot climate, blue distances, dried grasses, special light and colour

I was lecturing in Australia in November 1989 and Gill and I had a marvellous time staying with the well-known Australian watercolour painter Bob Wade at his house in Melbourne. We did some painting together on the outskirts and then Bob and his wife Ann took us to stay at their country house at Cape Shanck on the coast west of Melbourne.

We passed through some stunning country, rather flat with no fences, just wild grassland going on for miles and scattered all over with superb old gum trees. I stopped the car at odd times for about three minutes to do a lightning sketch, for example, **Figure 98** *Gum Trees and Small Barn*. The white trunks were twisted into fascinating shapes.

We visited a lovely spot, shown in **Figure 99** *Old Barn and Fir Trees, Hamilton*. Bob Wade can be seen close to the barn painting at his easel, while I was further back painting the same scene. This was a very tall barn by Australian standards; most of them are low, long buildings.

On the way back to Melbourne, Bob pointed out to

98 *Gum Trees and Small Barn, Australia*

us the very good view shown in **Figure 100** *Grampian Mountains and Gum Trees*. This painting shows very characteristic Australian colouring.

Having delivered my lecture in Melbourne, we flew on to Sydney for another lecture. We met many very keen Australian watercolour artists in both Melbourne and Sydney.

I had been asked to give

demonstrations at a painting school called the Warriwillah Art Centre, where residential painting courses are held throughout the year. I readily accepted this invitation and we were duly met in Sydney by Elaine and Ian Mortimer who own and run the school.

100 *Grampian Mountains and Gum Trees.*
317 mm × 476 mm ($12\frac{1}{2}$ in × $18\frac{3}{4}$ in)

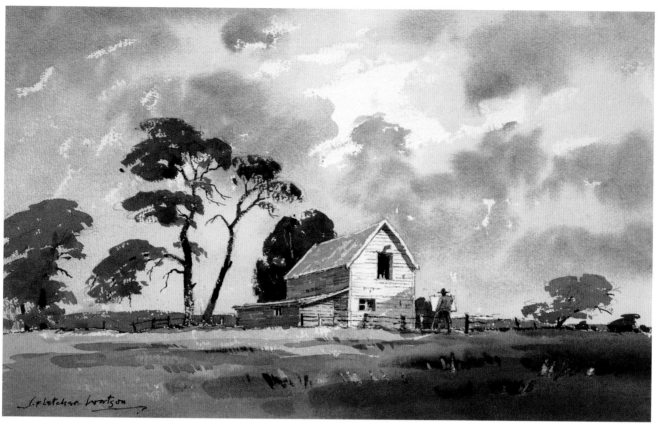

99 *Old Barn and Fir Trees, Hamilton, Australia.* 317 mm × 476 mm (12½ in × 18¾ in)

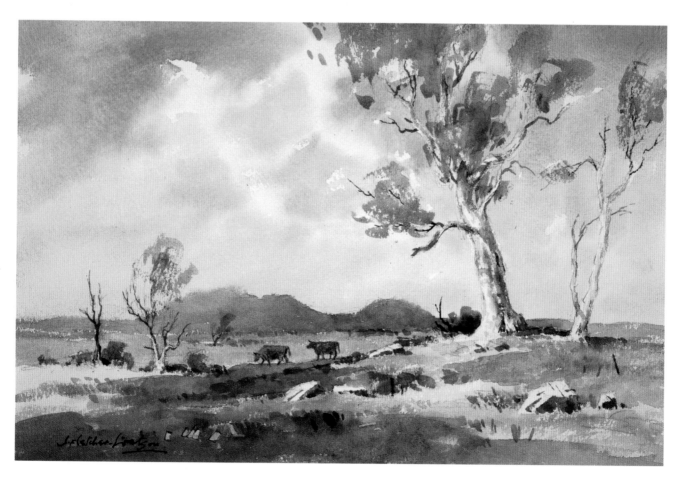

The brick-and-timber building in **Figure 101** *The Studio, Warriwillah* had a beautiful studio and upper-floor gallery. Elaine is herself an excellent watercolour painter; Ian is a farmer and the school is in lovely open country. Their nearest small town is Millthorpe, about 320 km (200 miles) from Sydney. The journey took us through the spectacular Blue Mountains.

The lovely dusty country road through trees seen in **Figure 102** *Wooded Road, Springhill* was only a few miles from the Warriwillah Art Centre. It was very hot

101 *The Studio, Warriwillah*

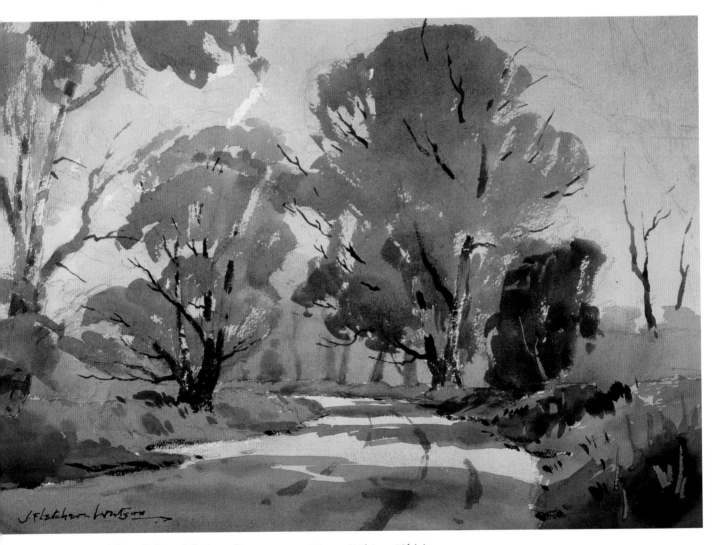

102 *Wooded Road, Springhill, Australia.* 317 mm × 476 mm (12½ in × 18¾ in)

weather but my painting group and I had an enjoyable time, keeping in the shade as much as possible and working fast as the paint dried quickly on the paper. I found the composition of this picture particularly satisfying. It took about 1¾ hours to paint. I found that by using more water than usual in my mixes and applying the washes with quick brush strokes, I got over the problem of the paint drying too quickly in the heat.

Not far from Millthorpe, I found a good subject: a delightful group of trees near a pond and a blue distance beyond, shown in **Figure 103**. I am looking forward to painting a picture from this pencil sketch in the studio at home one day. Further afield to the west, the country began to get pretty wild and remote, and I discovered the lovely subject shown in **Figure 104** *Australian Outback, Gum Tree and Old Wagon.*

25 Nov. 89 Near Warriwillah.

103 *Trees near Warriwillah*

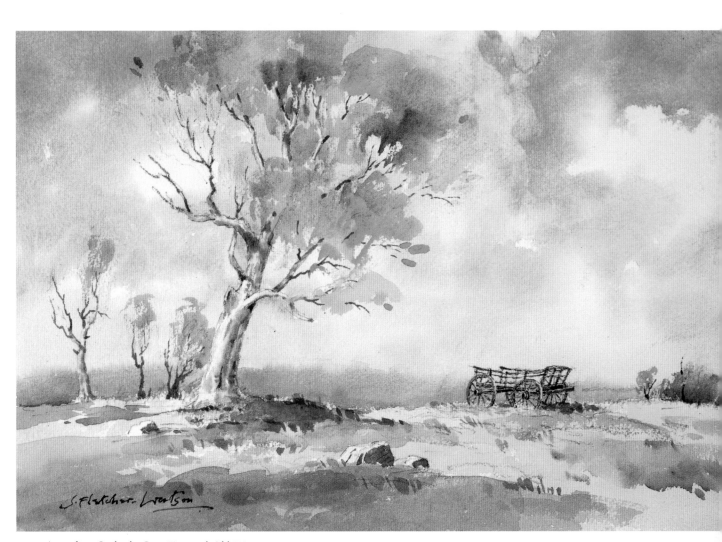

104 *Australian Outback, Gum Tree and Old Wagon.* 317 mm × 476 mm (12½ in × 18¾ in)

I think it is time I gave you a few details of how these gum-tree subjects are painted. The finished painting shown in **Figure 107** *Australian Outback with Gum Trees* is a good example. First we will look at **Figure 105** (*Stage 1*). I selected a piece of Winsor and Newton paper which, as I have said previously, is slightly absorbent and slightly cream in colour. Using a 2B pencil, I quickly sketched in the two large gum trees with a fairly firm line for the trunks so that I could paint round them and not over them. (I was not going to use masking fluid for this picture.) The rise in ground was an important feature. The rocks were also sketched in at this stage.

I used *French Ultramarine* for the sky, leaving areas of white cloud and making the wash weaker towards the horizon, adding some *Raw Sienna* near the horizon. The main point was to leave the tree trunks perfectly white and untouched.

In **Figure 106** (*Stage 2*) I painted the far-distant low hills, using *Cobalt Blue* and *Light Red* to give a blue-grey. I blurred the top edge into the sky, using clear water and a no. 5 brush, to give the necessary distant haze. The flat plain of yellowish grass and general scrub was painted with *Raw Sienna* and a touch of *Burnt Umber*.

Next I painted the bush close to the foot of the large right-hand tree, and also the small right-hand tree foliage and the other bushes, with *Cobalt Blue* and *Raw Sienna*. The rocks were given a shadow colour of *Cobalt Blue*, *Indian Red* and *Raw Sienna*.

105 Stage 1 of painting Figure 107

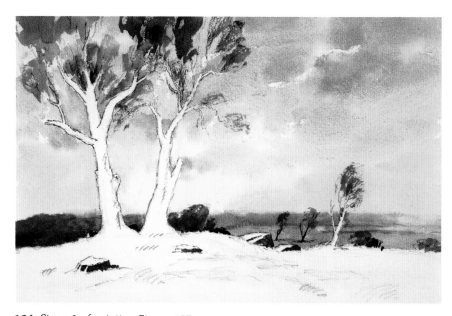

106 Stage 2 of painting Figure 107

The foliage for the two large trees was the next item. For this I used a larger brush and a varying mixture of *Raw Sienna* and a little *Cobalt Blue*. This was dragged brushwork, using a fairly dry mixture. I took care to leave the tree trunks untouched.

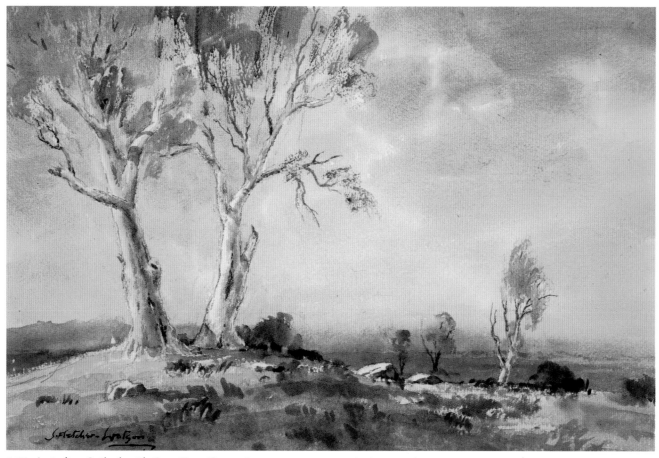

107 *Australian Outback with Gum Trees* (Stage 3). 317 mm × 476 mm (12½ in × 18¾ in)

In **Figure 107** (*Stage 3*) I now painted the shadows on the sides of the tree trunks, using a no. 6 brush and various mixtures of *Raw Sienna, Cobalt Blue* and *Payne's Gray*, and some *Burnt Umber* for the vertical cracks in the bark. I softened the edge of the shadows with clear water. The trunks of the smaller trees were also painted.

The foreground was the final stage, using a no. 9 or 10 brush and a variety of colours for different mixes: *Raw Sienna, Burnt Sienna, Burnt Umber, Cobalt Blue* and even a dash of *Rose Madder* near the foot of the right-hand trunk. The dead grasses and tufts needed different colours, as you can see. Finally, I put in a few shadows of branches falling across the tree trunks.

There is a special beautiful light in Australia which is difficult to define. Objects in a landscape seem brilliantly clear and sharp, and yet there can be a heat haze and distant hills can be blurred.

The colours used for this picture were:

1 *Raw Sienna*, 2 *Burnt Sienna*, 3 *Burnt Umber*, 4 *Light Red*, 5 *Indian Red*, 6 *Rose Madder*, 7 *Cobalt Blue*, 8 *French Ultramarine*, 9 *Payne's Gray*.

108 *Francis Street, Sydney*

Back in Sydney, I was able to explore some of the back streets of the older parts of the city. We found some good cafés and also some lovely old terrace houses. **Figure 108** *Francis Street* shows early nineteenth-century houses, which look like Regency houses in England. **Figure 109** *Francis Street* shows a few more houses further down the hill — all charming little dwellings, deserving a watercolour painting one day.

109 *Francis Street, Sydney*

12

CUMBRIA

Mists and mountains, farmhouses, lakes and reflections

GILL and I are fairly regular visitors to Cumbria, and Borrowdale is one of our favourite spots. It is one of the best centres for being able to get to a variety of very paintable places. **Figure 110** *Seatoller House, Borrowdale* nestles at the foot of the Honister Pass.

This painting was made on a day when I had to have my sketching umbrella in action. The clouds were low and the mist kept sweeping across with intermittent rain showers. If you had been sitting indoors in a town you would have thought what a completely unpaintable day it was! But there the colours were wonderful and there were even gleams of sun from time to time. When I had three-quarters finished the wind was beginning to blow the rain under the umbrella, so I decided to pack up and finish the painting indoors. This picture shows what I call the magic of Cumbria; you only get it here and in places like Wales and Scotland, and you can only capture it by painting out of doors, which is of course what this book is all about.

A few miles west of Seatoller village over the Honister Pass is Buttermere, and there are many

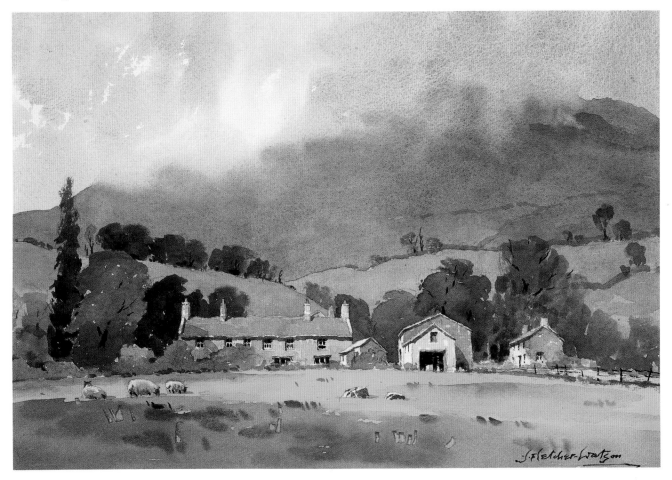

110 *Seatoller House, Borrowdale.* 317 mm × 476 mm (12½ in × 18¾ in)

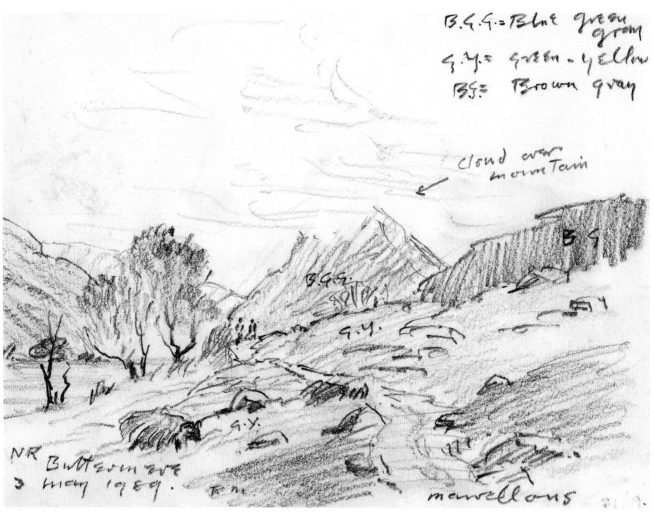

111 *Near Buttermere, Cumbria*

good views for painting in this area. **Figure 111** is a pencil sketch of a walkers' track between Buttermere Lake and Crummock Water. I was very struck with this view and made notes of some of the colours. Although later I was able to make a painting on the spot, the sketch remains for me to do a picture from at a much later date if I want to. I hope I can encourage my readers to make similar sketches.

Moving away to the east to a spot just north of Ullswater, I found a good simple subject for a demonstration picture, shown in **Figure 114** *Dacre Farmhouse* (see overleaf). **Figure 112** shows *Stage 1*. The time of year was early autumn.

I chose Whatman 200 lb Rough paper and first decided on the composition. I made an invisible drawing, using my forefinger like a pencil. I made a rectangle where I wanted the farmhouse on the right, then came the road slanting down to the left and the large tree left of centre. I had saved myself the bother of making a pencil sketch and had also saved making pencil marks on the paper that might have been wrong.

I drew the farmhouse rather carefully with a 2B pencil, and lightly sketched in the lines of the road, the trees and the low mountain behind.

Painting now started. I dampened the sky area and ran in a wash of *French Ultramarine* and *Burnt Umber* to give a light grey for the clouds, of course leaving spaces of white paper for the light clouds. While it was still wet, I dropped in *Raw Sienna* in one place and *French Ultramarine* in one or two others. This sky wash was now allowed to dry.

Next the distant mountain was washed in with *French Ultramarine* and *Light Red* followed by a well-diluted wash of *Raw Sienna* all over the foreground.

In **Figure 113** (*Stage 2*) the trees and the high hedge came next. I used *Raw Sienna, Winsor Blue* and *Burnt Sienna* for most of these, but for the darker areas, such as the ivy-clad tree trunk and the other tree trunk and

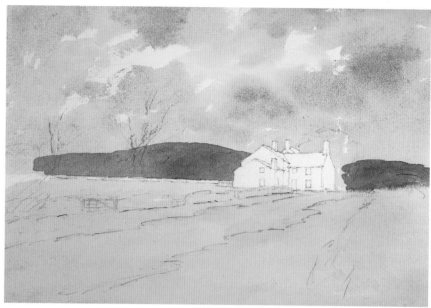

112 Stage 1 of painting Figure 114

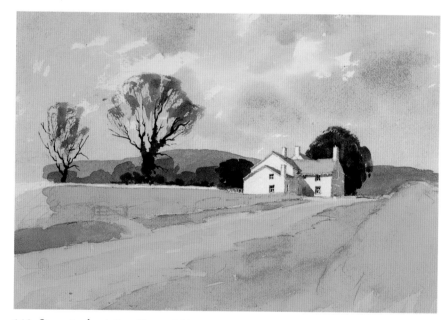

113 Stage 2 of painting Figure 114

foliage behind the house, *Burnt Umber* was added to the mixture.

A further green wash of *Cadmium Yellow* and *Winsor Blue* was laid on the fields. I made this mixture stronger for the grass verges by adding *Raw Sienna*.

The house roofs were painted with *Winsor Blue* and *Indian Red*

and the wall shadows with *Cobalt Blue* and *Light Red*. The windows were *Burnt Umber* and *French Ultramarine*.

I 'lifted' part of the right-hand end of the mountain with my bristle brush and blotted this area as I wanted a foreground green bush to overlap here.

In **Figure 114** (*Stage 3*) I put
in the hedge on the far side of
the road with a mixture of three
colours: *Raw Sienna*, *Winsor Blue*
and *Burnt Sienna*. I could vary the
tone considerably as desired. The
bush on the extreme right was
painted with the same mixture
but with *Burnt Umber* added in
the dark places. The gate and bits
of fencing and the earthy edges
to the grass verges were painted
with *Burnt Umber* and a touch of
French Ultramarine, using a
smaller brush, of course.

I strengthened the grey
shadows on the house and added
the figures of a man and a dog.
There was a little grass along the
centre of the road; a touch of
Raw Sienna and *Winsor Blue* was
right for this. Finally, there were
some cloud shadows falling
across field and road. I used
Cobalt Blue and *Light Red* for the
road, and for the grass areas
simply a darker green of the
original mixture.

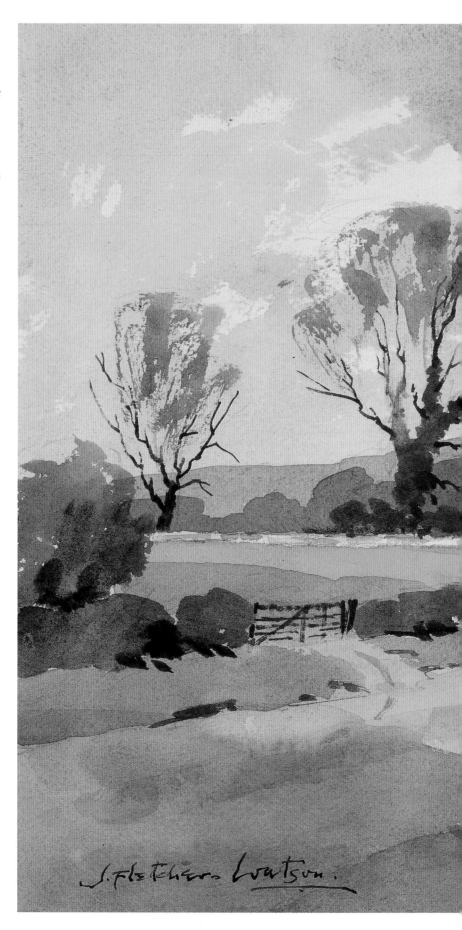

114 *Dacre Farmhouse, Cumbria* (Stage 3).
317 mm × 476 mm (12½ in × 18¾ in)

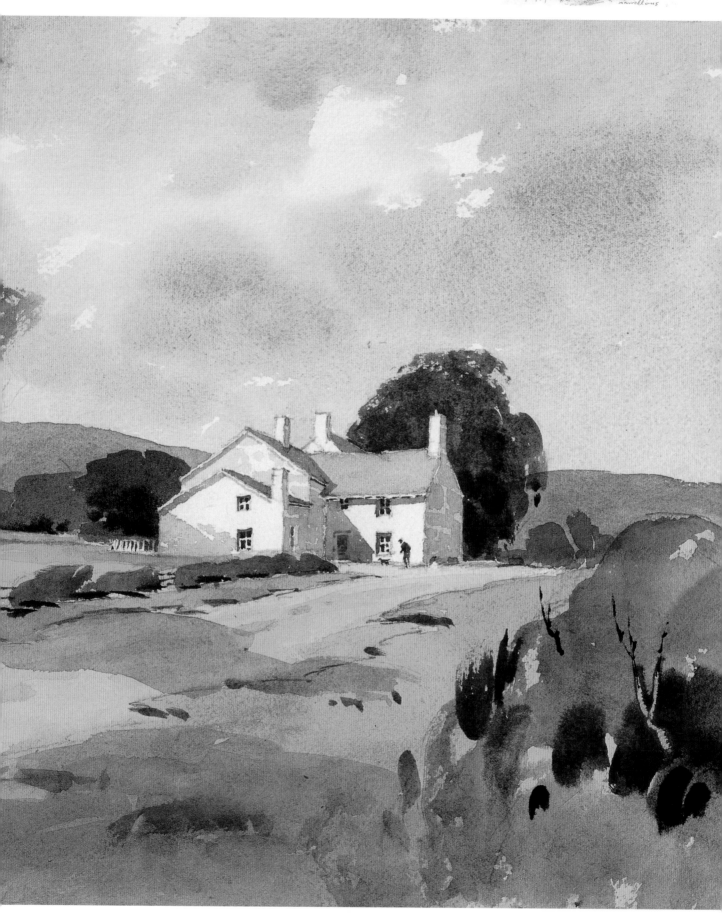

115 *Gatesgarth Dale, Cumbria*

Figure 116 *Gatesgarth Dale* is a subject I have painted before but a more distant view. I had always wanted to do a close-up showing the drop gate which keeps sheep from passing through. I decided to make a quick pencil sketch first to check whether the composition was all right, and this can be seen in **Figure 115**. It was a perfect little view but I wanted the sun further round to darken the mountains more, so we decided to have our sandwich lunch first and then I could get on with it.

It was a fast-moving stream with the water going away from me. In colour it was pure *Payne's Gray* with a touch of *Raw Umber* – a good exercise in painting moving water.

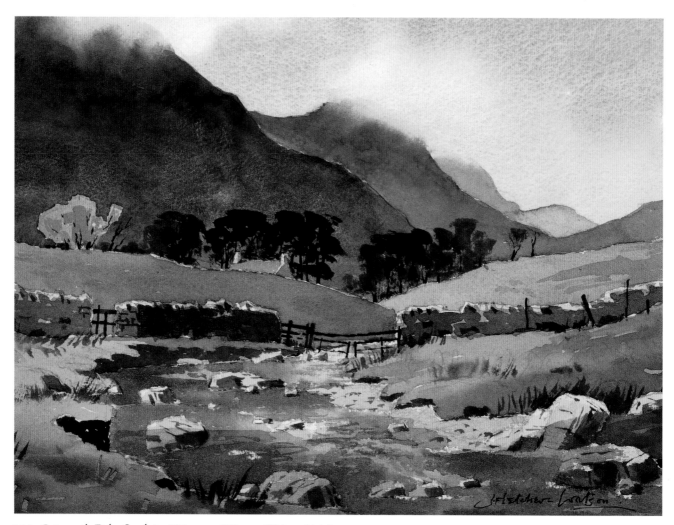

116 *Gatesgarth Dale, Cumbria.* 235 mm × 355 mm (9¼ in × 14 in)

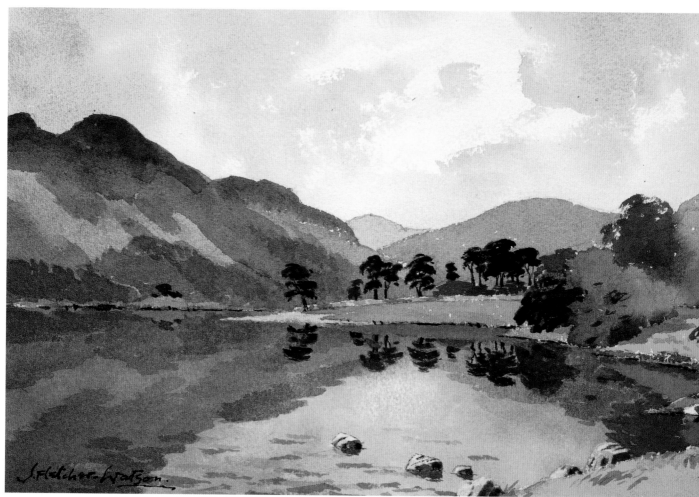

117 *Buttermere, Cumbria.* 235 mm × 355 mm (9¼ in × 14 in)

Figure 117 *Buttermere* was a complete contrast to the last picture, a calm day with no wind and perfect reflections. The time of year was May with lovely colouring. I recommend this subject to all of you who are thinking of visiting the Lake District, but be careful to get your vertical measurements right for the reflections. Keen observation is necessary.

Figure 118 *Crummock Water* was a quick pencil sketch, no time for more, but a lovely subject which I painted when I got home. My note on the drawing says 'yellows and browns': that was enough to give me a guide. The lake is next door to Buttermere.

118 *Crummock Water, Cumbria*

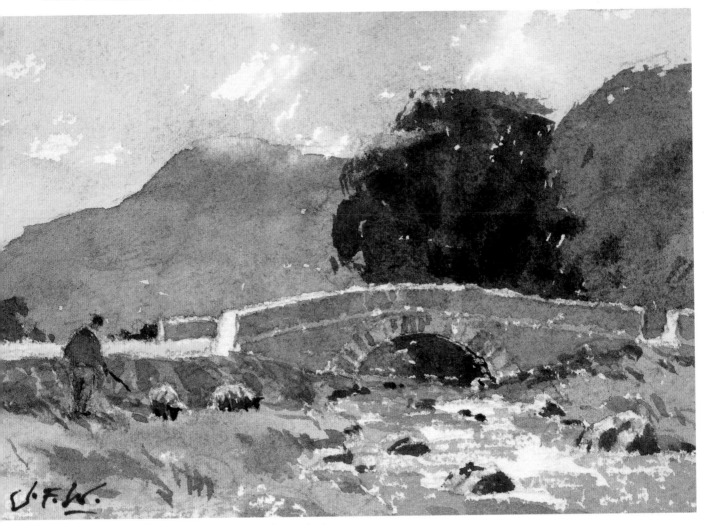

119 *Mosedale, Cumbria.* 95 mm × 140 mm (3¾ in × 5½ in)

Figure 119 *Mosedale* is a very small picture to end with (shown here larger than actual size), measuring only 95 mm × 140 mm (3¾ in × 5½ in). It took twenty-five minutes to paint. Note the economy of brushwork – just a simple statement with good tone values.

13

DURHAM

Historic views of Durham Cathedral and Castle

AFTER a painting tour in Cumbria in 1991, Gill and I turned east for a visit to Durham, something we had wanted to do for years. I am glad to say I was not disappointed by the amazing prospect of Durham Cathedral and Castle towering aloft on its rocky height as I looked at the view from the banks of the River Wear, shown in **Figure 120** *Durham Cathedral and Castle from the North-West* (see overleaf). I was pleased to find that this famous view still remains more or less intact and that no unsuitable recent building has protruded. I have a print of a watercolour of this view by Thomas Girtin, probably painted about 1800. Some of his houses look a bit older than what is there now but the present ones are reasonably in keeping, even though some of them may only be fifty years old or less.

The day was threatening rain, with a breeze and passing clouds changing all the time, patches of blue and occasional sunshine. I had an overhanging ledge of building above me so I felt reasonably safe from rain.

Drawing of course came first; I was using Whatman heavy-weight Not paper. The composition was fairly obvious: the cathedral and other buildings had to be on the left with the bridge slung across to the right, ending in low groups of trees.

The bridge had a wonderful stabilizing effect, holding together the buildings and stopping the groups of trees from slipping down.

The foreground weir was played down so as not to compete with the bridge. Using a B pencil, I drew in the towers, buildings, windows, etc. fairly carefully and the bridge quite firmly.

I thought about the sky before I started painting as I wanted it to be sympathetic to the buildings. The sun was coming from the right and every now and then it caught some of the towers while other structures went into cloud shadow. I designed a sky in my mind with patches of blue in the centre and to the right. Using my squirrel brush, I mixed a large pool of grey in my paintbox, using *French Ultramarine* and *Burnt Umber*. This was washed all over the sky, leaving plenty of white areas to start with. I painted in some blue patches with *French Ultramarine*, watered down a bit, then I increased the strength of the grey and added darker clouds in judicious places. I painted round the buildings, not over them.

Next I laid a light wash of diluted *Raw Sienna* over the buildings, trees and bridge but left the highlights white and untouched. That included the top edge of the bridge.

I then systematically filled in all the buildings, including the castle and cathedral, with a variety of warm stone and brick colours, using various mixes of *Raw Umber*, *Burnt Sienna* and *Burnt Umber* and toning them down with *Payne's Gray*. This was followed by the roof colours, using *Cobalt Blue* and *Burnt Sienna*. I carefully left the walls and roofs that were catching the sunlight unpainted at this stage. The windows were painted next in dark and medium-dark tones of *Burnt Umber* and *French Ultramarine*. The shadows of the buttresses, and under the roof eaves, etc., were painted with *Cobalt Blue* and *Light Red*, giving a warm grey.

The trees were painted with mixes of *Raw Umber*, *Winsor Blue* and *Burnt Sienna*. Some tree groups were very dark, being in cloud shadow, and *Burnt Umber* was introduced for these.

The grass bank on the far side of the river and a light patch of trees at the top left were painted with *Cadmium Yellow* and *Winsor Blue*. There was a lot of merging of colour groups during the process of tree painting. The distant building and the trees seen through the right-hand bridge arch had their colours modified with *Cobalt Blue* and *Light Red*.

Next the bridge was painted with mixtures of *Burnt Umber* and *French Ultramarine*. Care was

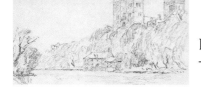

taken to leave the top edge, and the left sides under the arches, catching the light.

The right-hand low trees were then dealt with, in colours similar to those used for the trees on the left.

Getting near the end of the painting work, I could put in a wash of light *Payne's Gray* on the river, leaving an untouched streak in the distance which was catching the light, and leaving white patches on the rough water of the weir. When this was dry, I washed in a darker tone of *Payne's Gray* with a little *Raw Sienna* added over the nearer areas of water. The rocks and broken branches on the weir were painted with *Burnt Umber* and *Cobalt Blue*, mixed fairly stiffly.

I painted some cloud shadows on the castle walls and the main cathedral tower, using *Cobalt Blue* and *Light Red*, and a little *Indian Red* in parts. The cloud shadows on the trees were emphasized with the same colour.

Finally the figures and the boat on the water were painted, along with the foreground rocks.

It is not possible to describe every detail of painting in a fairly complicated picture like this. You have to read between the lines a bit, but I hope I have given you the general gist of my method.

The colours used were:

1 *Cadmium Yellow*, 2 *Raw Sienna*, 3 *Raw Umber*, 4 *Burnt Sienna*, 5 *Burnt Umber*, 6 *Light Red*, 7 *Indian Red*, 8 *Cobalt Blue*, 9 *French Ultramarine*, 10 *Winsor Blue*, 11 *Payne's Gray*.

It took about three-and-a-half hours to paint, including the drawing which took about an hour.

120 *Durham Cathedral and Castle from the North-West.* 317 mm × 476 mm (12¼ in × 18¾ in)

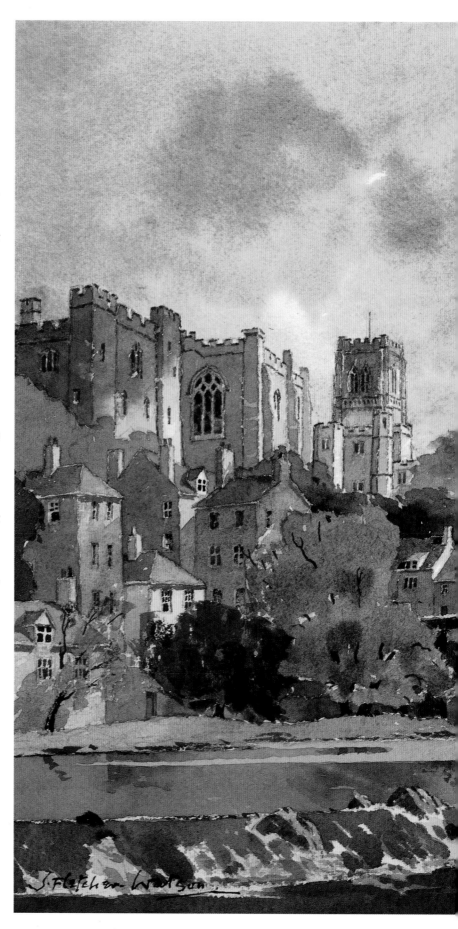

We explored the old city of Durham. The Cathedral Close on top of the hill was particularly attractive, and when I went further upstream along the river I found another stunning view of the cathedral and the old watermill beneath it.

I made a rough pencil sketch of this view, shown in **Figure 121**. It was drizzling at the time so it is not a very good drawing, but it was enough to tell me that this was another winning subject that I *must* paint.

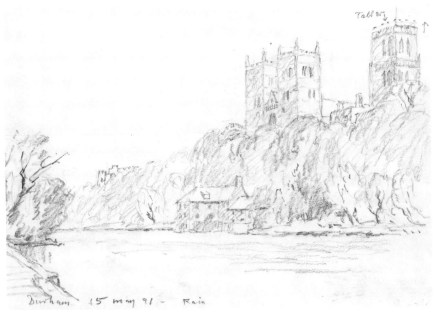

121 *Durham Cathedral from the South-West*

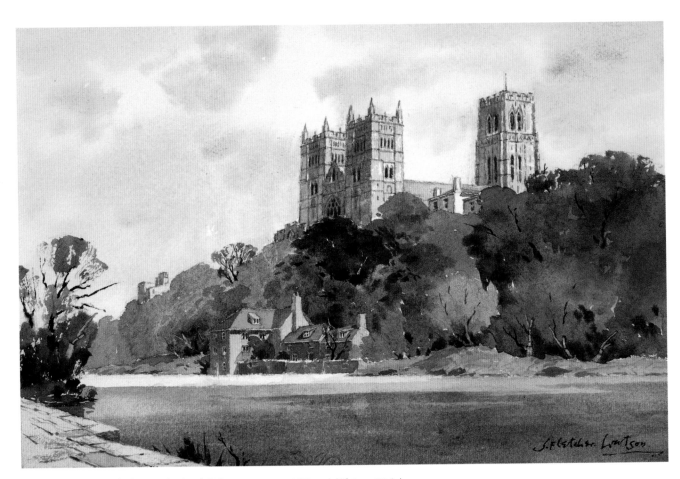

122 *Durham Cathedral from the South-West.* 235 mm × 355 mm (9¼ in × 14 in)

The finished painting, seen in **Figure 122** *Durham Cathedral from the South-West*, was done on the spot. The presence of the old watermill and cottages on the water's edge makes the whole group of buildings a very fine composition.

14

YORKSHIRE

Rivers, bridges and castles

YORKSHIRE is the most amazing county for variety of subject, which is perhaps not surprising as it is England's largest county. For this chapter I am concentrating on north Yorkshire.

Hubberholme is a delightful little hamlet on the River Wharfe. It is in the heart of the Yorkshire Dales and there are many subjects for the painter in and around it. When we arrived, I looked at several possible views. I was undecided on what to choose, so I made the quick pencil sketch shown in **Figure 123**. It was morning and the shadows seemed to be good. It took about fifteen minutes and convinced me that it was an excellent composition. I at once got my equipment from the car and settled down to painting the

123 *Hubberholme, Wharfedale*

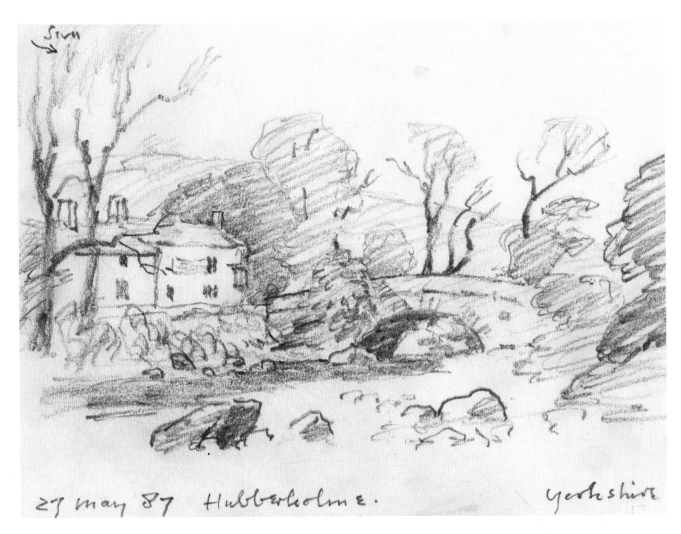

27 May 87 Hubberholme. Yorkshire

113

picture shown in **Figure 124**
Hubberholme, Wharfedale.

I drew the cottages, the inn on
the corner and the bridge quite
carefully, and then quickly
sketched in the trees, the distant
hill and the dry-riverbed
foreground on which I was
sitting. With half-closed eyes I
could see that the focal point of
interest was the dark group of
trees in the centre and the arch of
the bridge, so I decided to make
my darkest darks at these points.

First, of course, I started with
the cloudy, light grey sky which
was washed in on dampened
paper, using watered-down
Payne's Gray with a touch of
Cobalt Blue in places.

When this was dry, I could
paint the background hill with
French Ultramarine and *Light Red.*
Next the buildings were painted
with the same two colours, but
adding *Raw Sienna* to the
mixture. These cottages were in
shadow, but their roofs were
catching the sunlight so I gave
them a thin coat of *Cobalt Blue.*

I next put in all the various
trees. The centre group was *Raw
Sienna* and *Winsor Blue* for the
lighter half, adding *Burnt Umber*
for the darker tree. The trees on
the right were the same mixtures;
the ones on the left had less
Burnt Umber. The tree trunks and
branches were *Burnt Umber* and
French Ultramarine. The grass
bank was a light green, again
using *Raw Sienna* and *Winsor
Blue.*

At this point, I washed over
the river area, the foreground and
the stone bridge with a weak
mixture of *Burnt Umber* and
Payne's Gray. I left unpainted the
sunny side of the rocks and a few
patches of the bridge which were
in full sun. I could then drop in
the dark reflecting water of the
river near the bank, using *Burnt
Umber* and *Winsor Blue,* and the
foreground shadows over the

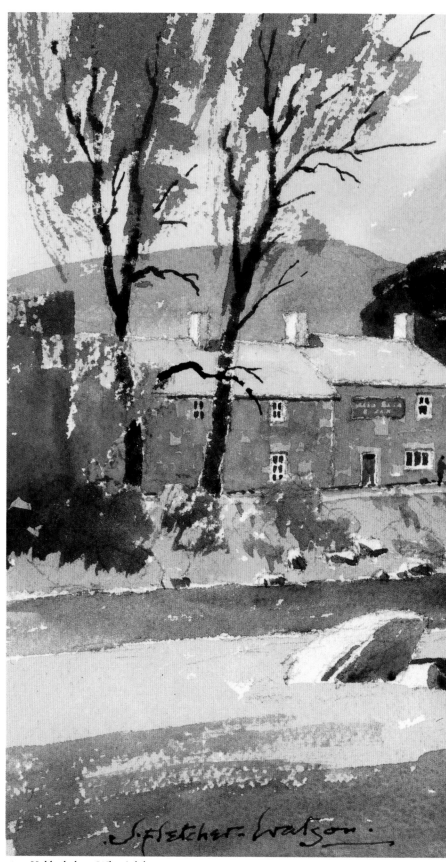

124 *Hubberholme, Wharfedale.* 235 mm × 355 mm (9¼ in × 14 in)

114

Castle Bolton
23 may 87

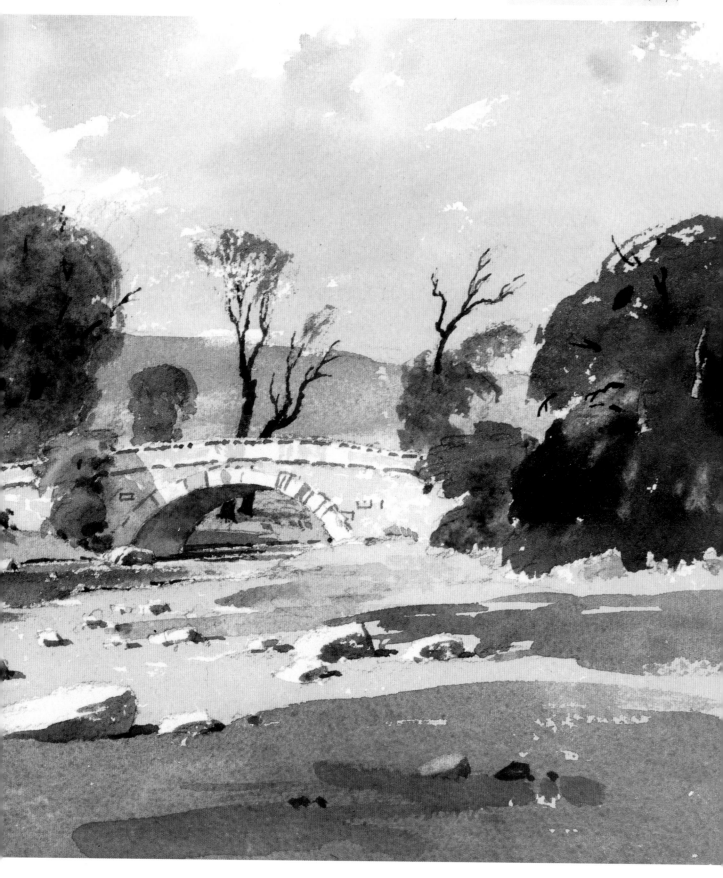

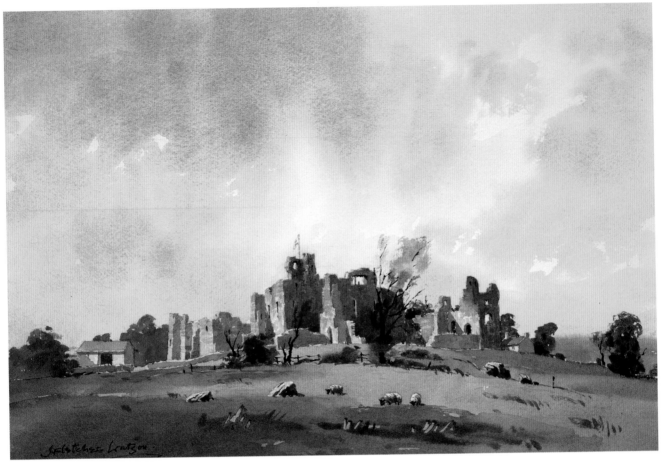

125 *Middleham Castle, Yorkshire.* 317 mm × 476 mm (12½ in × 18¾ in)

shingle beach with a wash of *Burnt Umber* and *French Ultramarine*. The shadows from the rocks and the underside of the bridge received the same colour, but in a stronger tone.

It only remained for the windows and doors to be touched in with a small brush, using *Burnt Umber* and *French Ultramarine*. The same mixture was used for the coping stones of the bridge and a few stone joints.

A year or two later we were in the same area of Yorkshire and we discovered the ancient village of Middleham and its fine castle ruins. I was able to make an on-the-spot painting of the castle, shown in **Figure 125** *Middleham Castle*. The weather was threatening rain so I played safe and sat in the car, which I had manoeuvred into an excellent position on the edge of the cricket ground.

Just briefly let me describe the painting process. It was a lovely cloudy sky, so with plenty of water I allowed my grey wash to run downwards, indicating rain showers. I allowed a small bit of blue at the top right corner.

The castle itself was a grey-brown colour. I used *Raw Umber*, *Burnt Sienna* and small amounts of *French Ultramarine* in mixtures, varying them from quite light washes to fairly dark paint on the shadow sides of the walls. We had a glimpse of sun now and then which gave a good sparkle.

The grass was cropped short by sheep; a wash of *Raw Sienna* and *Winsor Blue* was suitable for this. One or two rocks and some sheep were in evidence and I carefully left them white until the end.

The broken fence and the bushes and small trees running across the field were helpful features giving distance and perspective. I used *Winsor Blue* and *Burnt Sienna* for most of this. There were various cloud shadows on the grass, and finally I touched in the stronger shadows on the rocks and sheep. The rain did come just before I finished and I was glad to be inside the car.

Another castle quite close by is shown in **Figure 126** *Castle Bolton*. I am including this because it is a good example of a *subject-reminder* only, not good enough to do a painting from. I did it standing up in about three minutes. I did go back another time and paint this subject on the spot.

126 *Castle Bolton, Yorkshire*

127 *Bridge near Sedburgh, Yorkshire Dales*

Figure 127 is a pencil drawing of a view we caught sight of as we slowly drove along a small country road near Sedburgh. As we passed, I said I thought it was a really good view and we at once backed the car. It was a real gem! I made a preliminary sketch, then after our picnic I made the small painting

128 *Bridge near Sedburgh, Yorkshire Dales.* 140 mm × 196 mm (5½ in × 7¾ in)

shown in **Figure 128** *Bridge near Sedburgh.* The composition is so good, with the white-painted stone cottage, the grey bridge, a perfect group of trees giving darkness and depth through the bridge arch and the twisting little river tumbling along. The distant grey hill provides a good background.

15

SPECIAL POINTS

Mediterranean sunlight and shadows, parched landscapes, low tide, mud and reflections, deep snow, winter trees

IN this last chapter I have chosen a group of subjects that illustrate some of the points we have to look out for when painting brilliant light and strong shadows, selecting a focal point, placing figures and generally capturing the mood of nature.

The island of Crete has a wonderful light and the shadows of buildings and trees are very lovely and strong in tone. In **Figure 129** you can see a pencil sketch of a hill village Gill and I visited in the month of October. It was a preliminary sketch for composition purposes prior to making a painting. **Figure 130** *Anatoli Village, Crete* (overleaf) shows the finished picture and it is one of my favourites; I was sorry to part with it. I feel I have captured the spirit of Crete, the chunkiness of the white houses and the strong shadows. I worked fast, dashing in the washes as they dried quickly in the hot sun. I think you will

129 *Anatoli Village, Crete*

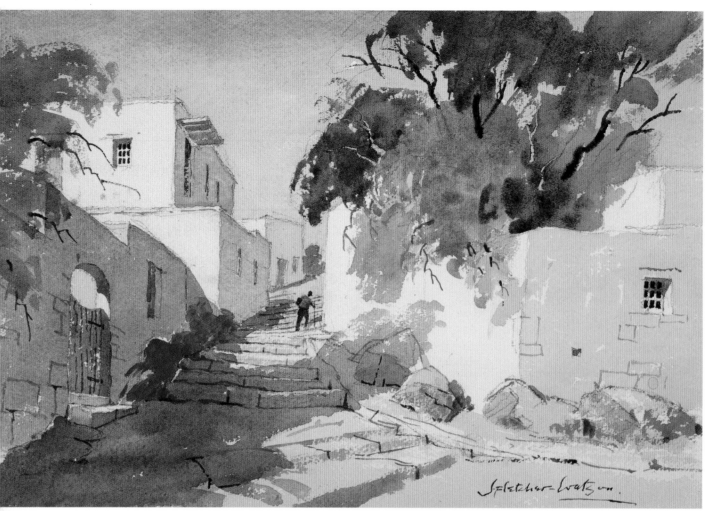

130 *Anatoli Village, Crete.* 317 mm × 476 mm (12½ in × 18¾ in)

agree that it makes a lovely composition.

 Figure 131 *Hill Village, Crete* is another good composition, with the old houses, the outside staircase and the mountain background. The old man with a goat came past while I painted. I used *Cerulean Blue* for the sky, which was a vivid greenish-blue. (I had used *Cobalt Blue* for the sky in **Figure 130**.)

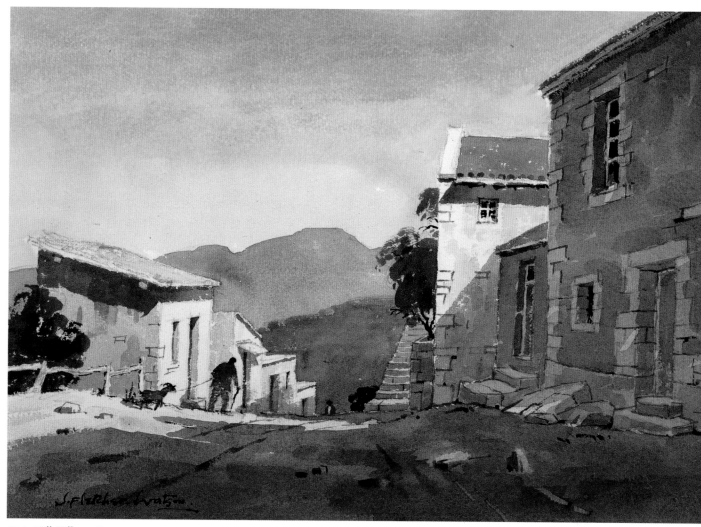

131 *Hill Village, Crete.* 317 mm × 476 mm (12½ in × 18¾ in)

The countryside of Crete is ravishingly beautiful. **Figure 132** is a quick pencil sketch of the Sitia range of mountains, from which I later made a painting.

132 *Sitia Mountains, Crete*

121

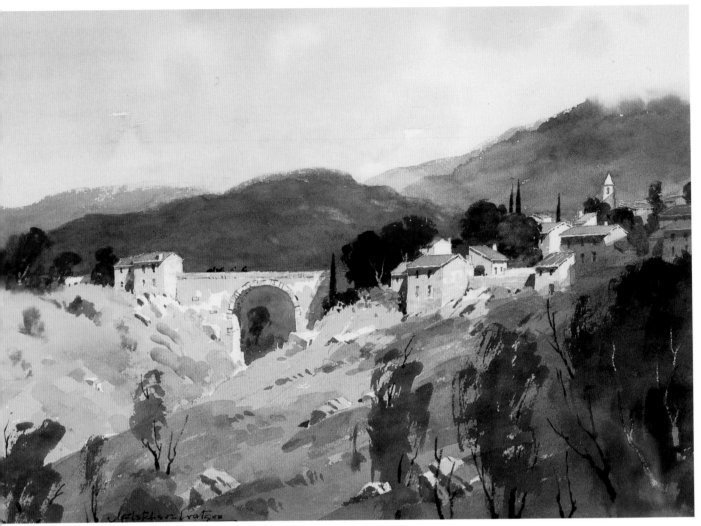

133 *Mountain Village, Sierra Navada.* 456 mm × 585 mm (16 in × 23 in)

Looking now at southern Spain, **Figure 133** *Mountain Village, Sierra Navada* was a large picture. Once you get into the mountain regions, the terrain becomes wild and rocky, and I found this village subject very exciting. I mostly used *Raw Sienna, Burnt Sienna* and *Burnt Umber*, with a touch of *French Ultramarine* where the colours needed toning down – for example, the large dark trees in the village near the bridge. They gave great accent to the houses, and there was a helpful tree shadow across one side of the bridge.

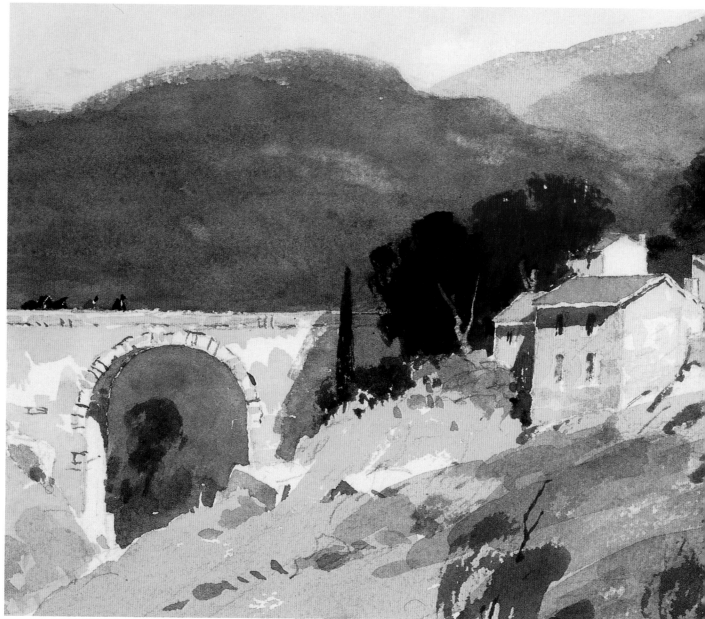

134 Detail of Figure 133

Figure 134 shows an enlarged
detail of this area, which was the
focal point of the picture. It was
a cloudy day, so there were
cloud shadows on the foreground
and on these trees, which helped
add to the depth of the picture.

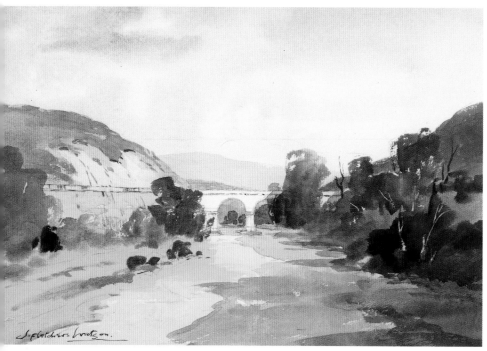

135 *River View, Sierra Navada.* 317 mm × 476 mm (12½ in × 18¾ in)

Driving one day from the south coast to Granada, we passed the lovely view shown in **Figure 135** *River View, Sierra Navada*. We never reached Granada, needless to say, as I could not resist painting this subject. The trees were autumn colours. The shingle beach was left the white of the paper, as were the stone bridge and the cliffs on the left.

Coming back to England, I have not said much about estuaries or mud, that ingredient much beloved by landscape painters! Round the coasts of Britain there are many estuaries, and what better place for a subject is there than **Figure 136** *Pin Mill, Suffolk*. This favourite mooring for Thames barges is on the River Orwell. It is a few miles from the mouth of the estuary but the river is tidal at this point and a great deal of gravelly mud is exposed at low tide. Before doing this painting I enquired carefully about the state of the tide, as it can come in quickly and then all could be lost! There are not many of these

lovely old barges left, but fortunately there are still quite a few keen sailing people who are prepared to spend money to maintain them.

What an attractive composition this is: the barge is, of course, the dominant feature and this was painted with strong, thick applications of paint, using *Burnt Umber* and *French Ultramarine*.

The old inn buildings come second in importance so I played down the tone strengths a little to push them back. The bank of late autumn trees was treated with a very simple wash of *Raw Sienna, French Ultramarine* and *Burnt Umber*. I first painted the cloudy sky using well-diluted *Payne's Gray*.

The all-important muddy foreground came almost last with a wash of *Burnt Umber* and *French Ultramarine*. I used a no. 8 brush, dragging it from right to left and feather-edging it for the waterline.

Finally came the water and reflections. I used *Payne's Gray* and a very little *Raw Sienna*,

136 *Pin Mill, Suffolk.* 317 mm × 476 mm (12½ in × 18¾ in)

giving the water a light-toned wash reflecting the sky colour. When it was dry I used a small brush for the reflections, with the same two colours but quite a strong, dark mixture.

I have not mentioned every single detail of the painting work

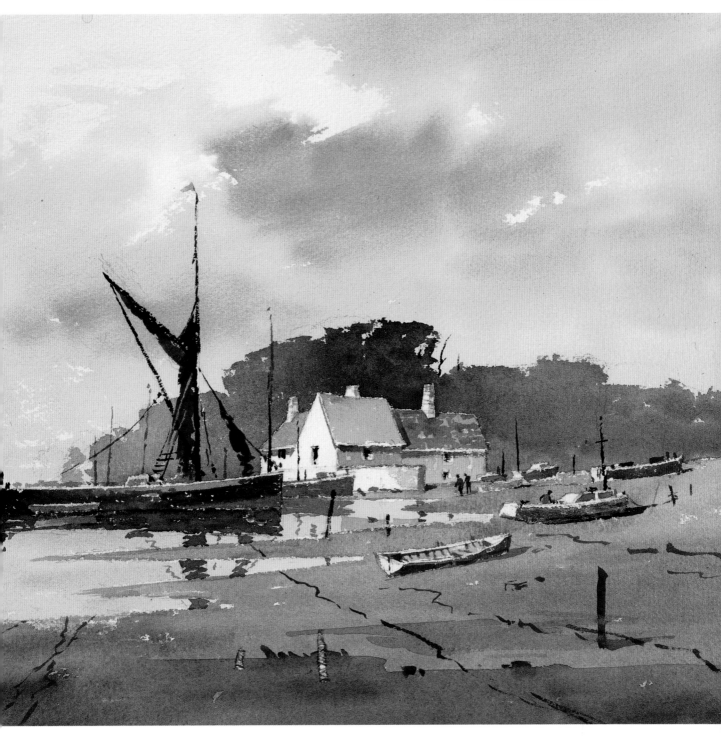

but enough I think to give you a guide.

What wonderful subjects our English farmhouses and farm buildings make for the painter, a lovely example of which is shown overleaf. Sad to say, far too many of these farm buildings are disappearing from the countryside, being allowed to fall down or converted into houses. I make an urgent plea that government planners at this eleventh hour should take steps to save this important heritage of ours.

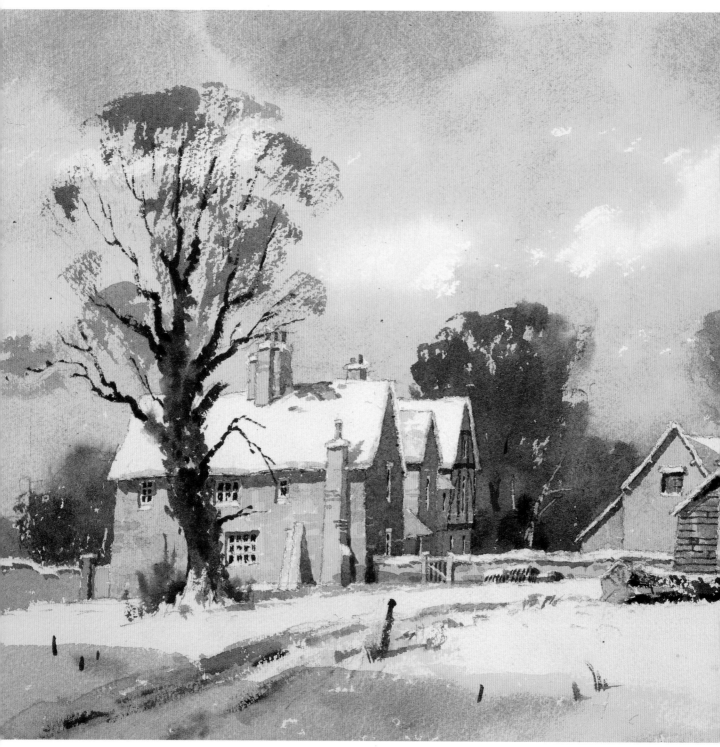

137 *Farm, Buckinghamshire.* 317 mm × 476 mm (12½ in × 18¾ in)

The farmhouse in **Figure 137** *Farm, Buckinghamshire* is Elizabethan. The mellow brick walls, some of which are half-timbered, are of most pleasing colours. The large barn on the right is entirely built of timber. The heavy fall of snow had a unifying effect, welding the buildings into the landscape, as snow always does. The dark winter trees made a lovely foil to the white snow.

I have spoken about painting trees in this book but perhaps not enough about winter trees. The large ash tree on the left has ivy growing up the trunk. First I painted the main trunk with a no. 6 brush and a dark brown mixture of *Burnt Umber* and *French Ultramarine*. As I worked upwards from the ground, I added the green ivy in *Cadmium*

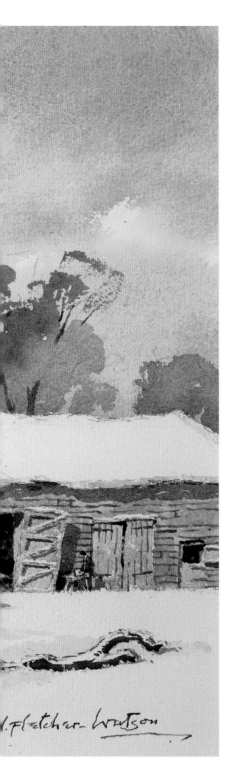

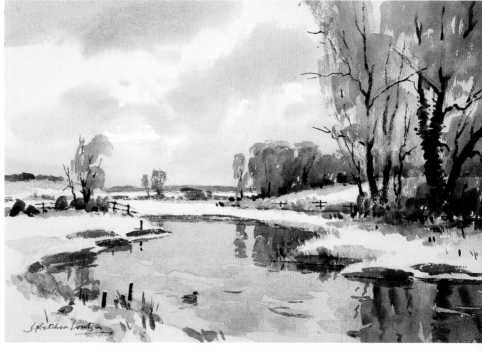

138 *River View in Snow*. 317 mm × 476 mm (12½ in × 18¾ in)

no. 10 brush, with a dry mix of *Burnt Umber* and *French Ultramarine*, and, starting at the top, I quickly dragged the brush downwards on its side to paint in the upper twig areas.

The more distant trees behind the buildings were painted with a no. 8 brush and the same brown mixture but varying the tone, the right-hand group being kept lighter. I added clear water with a separate brush to some parts of these trees to soften the edges and melt them into the background. The distant trees in the centre are mostly a *French Ultramarine* wash.

The real punches in this picture are the very dark barn opening on the right and the distant tree trunks in the centre.

Some more winter trees are shown in **Figure 138** *River View in Snow*. I chose this view for its attractive composition with a bend in the river and the disposition of the tree groups. They give excellent recession and also reflect well in the water. This loosely painted picture was done

on the spot, and I worked quickly so that I did not get too cold. First the sky was painted, stopping at the snow line on the horizon. Then the water was washed in, using the same blue-greys as the sky but a slightly darker tone. With water the lights are a little darker and the darks a little lighter. It is a good thing to remember this.

Having laid these two main washes in, the picture was almost half-finished as the white paper was working for me as snow!

The foreground right-hand trees were painted with *Burnt Umber* and *French Ultramarine*, using the large squirrel brush. One tree trunk was covered in ivy which I was pleased about; I treated it in the same way as the tree in **Figure 137**.

In this last chapter I have kept a little surprise for you. The picture in **Figure 138** was painted *with only two colours — Burnt Umber* and *French Ultramarine!* Try this out yourselves and you will learn a very valuable lesson in tone

Yellow, Winsor Blue and *Burnt Umber* and carried it up on to several branches. I then continued upwards with the dark brown for the smaller branches, then changed to a really small no. 2 brush for the topmost twigs. Finally I changed to a

127

values. These two colours, when mixed, give a very nice light grey, as used for the sky, and an excellent variety of dark browns for trees. And when *Burnt Umber* is well diluted it becomes a useful light, warm yellowish-brown for grass, etc.

I made the pencil sketch shown in **Figure 139** sitting on my small folding stool, which I often carry with me on a trip to London in case I find a moment to do a quick drawing. It was a November day but quite warm and sunny and an American tourist asked if she could buy the drawing! I am afraid I declined as I wanted to make a painting from it later.

Figure 140 *St James's Park and Buckingham Palace* is the finished painting which I made two years later. It is a lovely view, with the Palace seen across the lake and the Canada goose and ducks in the foreground.

140 *St James's Park and Buckingham Palace*. 235 mm × 355 mm (9¼ in × 14 in)

I made no notes about colours, yet I had no difficulty with the painting and I do not think my memory played me false in getting the different colour tones down on paper.

This is yet one more example showing the great value I find in filling my pencil sketchbooks whenever I get the chance. I hope I have encouraged many of my readers to do the same. I also hope I have persuaded many of you to do as much painting as possible actually out of doors. This, I am sure, is the secret of good watercolour painting – get close to nature and you will achieve great things.

139 *St James's Park and Buckingham Palace*

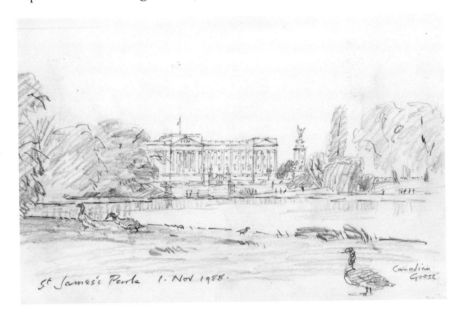